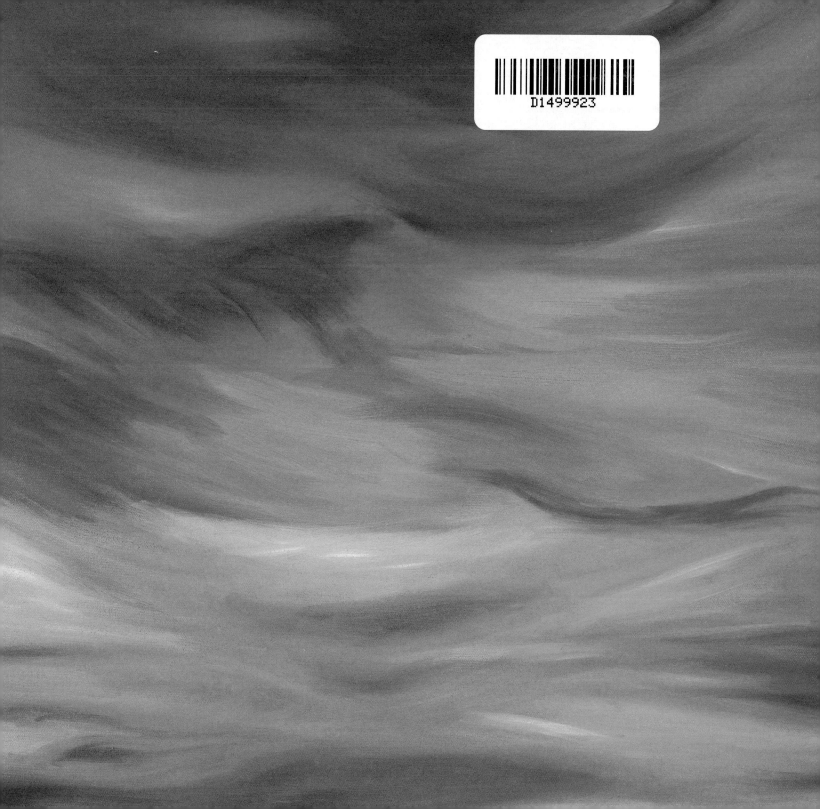

Sweet Bajan Days

AN ARTIST'S IMPRESSION OF BARBADOS

Gina Foster

MACMILLAN
CARIBBEAN

Macmillan Education
Between Towns Road, Oxford OX4 3PP
A division of Macmillan Publishers Limited
Companies and representatives throughout the world

www.macmillan-caribbean.com

ISBN 0 333 92548 3

First published 2004

Designed by Gary Fielder at AC Design
Illustrated by Gina Foster
Cover design by Gary Fielder at AC Design
Cover illustration by Gina Foster

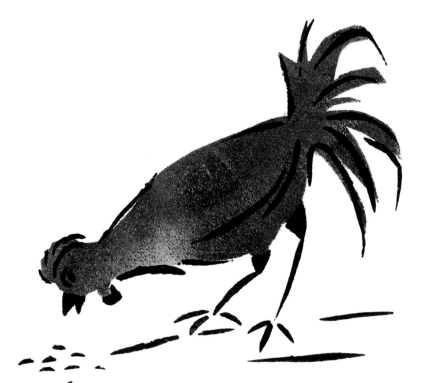

Printed and bound in Malaysia

2007 2006 2005 2004 2003
10 9 8 7 6 5 4 3 2 1

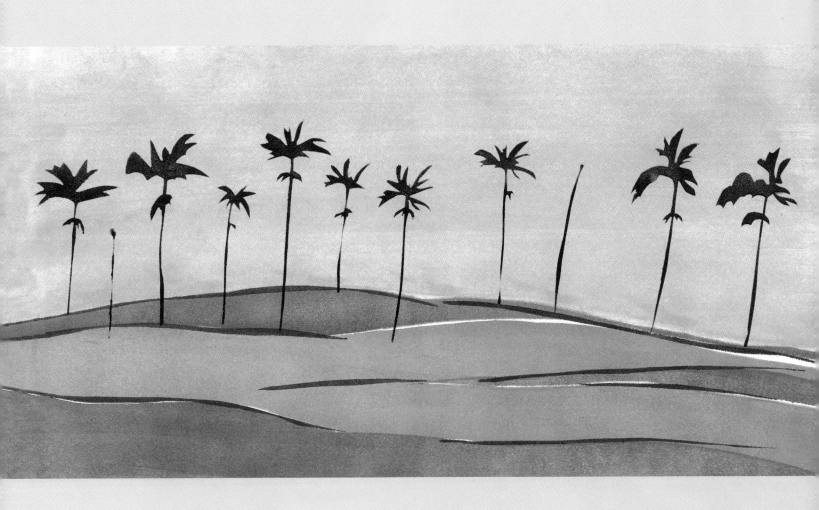

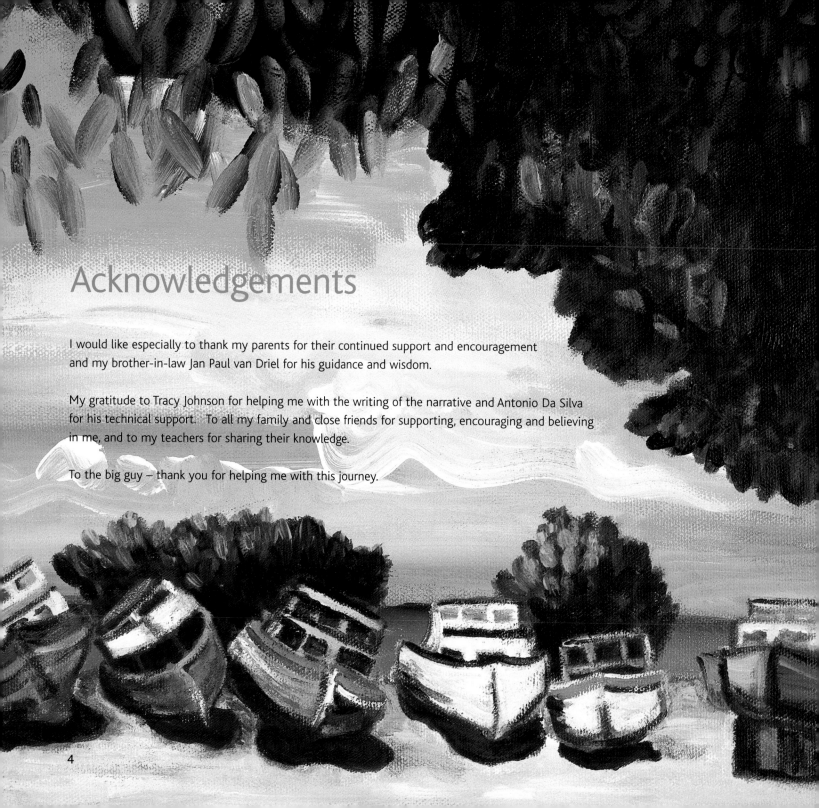

Acknowledgements

I would like especially to thank my parents for their continued support and encouragement and my brother-in-law Jan Paul van Driel for his guidance and wisdom.

My gratitude to Tracy Johnson for helping me with the writing of the narrative and Antonio Da Silva for his technical support. To all my family and close friends for supporting, encouraging and believing in me, and to my teachers for sharing their knowledge.

To the big guy – thank you for helping me with this journey.

NORTH POINT

SPEIGHTSTOWN

BATHSHEBA

HOLETOWN

THE CRANE

BRIDGETOWN

HASTINGS

OISTINS

GINA 2002

Barbados for good

I first set foot on these shores at the tender age of two. We spent several summer holidays here before moving to Barbados in 1974 'for good' – as we Bajans would say. I consider myself a Bajan. I was born in Guyana but became a Citizen of Barbados at the age of 9. This is where I was educated, lived for the majority of my life and still continue to live.

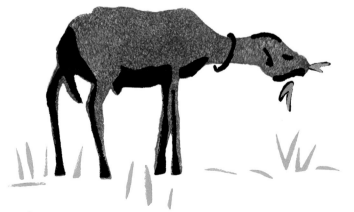

Barbados has a charm of its own, a spell that binds you to its shores and, once you have experienced its spell, you will always return. It has something to offer everyone. It is the most easterly-situated island in the Caribbean and, whereas the other islands are volcanic, Barbados is a limestone island. We are flanked by the Atlantic to the East and the Caribbean Sea to the West.

One thing I have learnt in almost 30 years as a Citizen of Barbados is that Barbadians are a proud people. Religion, gossip, cricket and 'no problem, man' are all a rich part of our culture. I wrote a poem, when I was studying and living in England and a wee bit homesick about my remembrance of Barbados. My tutor kept saying, 'What is the first thing that you see when you get off the plane?' and the thought that came to

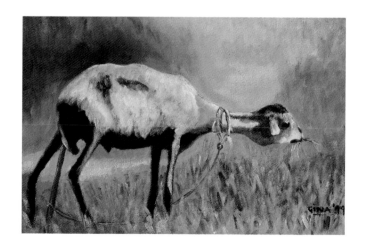

mind at that moment was not an image but a smell. A smell of the warmth of the earth, the smell of the air after it had rained, that tropical rain smell. And an ache in my heart to be there, to smell the smells and see the ocean. And hence this poem and a book 'I Live Here' was born:

I Live Here

I remember a land of green bathed in gold,

of winding paths meandering through fields of cane leading to a sea of blue,

of warm smiles and friendly people,

of echoing footsteps of running school children as laughter and chatter fill the air,

the call of the fisherman 'Flying fish 5 fuh a dolla!'

and the vibrant colours as the market wakes 'Eddoes, sweet potatoes, come all ah wunna!'

of voices rejoicing at Sunday Mass, praising God, 'Alleluiah'

As these images float through my mind, I can feel the water lapping at my feet, smell the warmth of the air.

As I travel this land where time is no problem, I realise I am not just passing through.

This is my home. I live here.

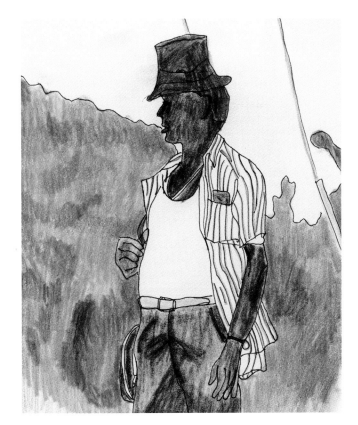

Creativity has always been a part of my life from a very young age. My grandmother painted, flower-arranged and embroidered the most beautiful dresses when we were growing up. I myself first took my artistic interests seriously only when I was introduced to photography in my latter years at secondary school, but it was not until I decided to leave the shores of Barbados in my twenties to travel that I finally followed my dream to make my hobby into a full time career. I spent six years in England, where I pursued my photography and continued to degree level in Graphic Design, specialising in Illustration. It was during this time in England, being away from my home, that I truly appreciated the peacefulness and beauty of Barbados.

I have since returned home. I often drive around the island, taking photographs, sketching, gathering information. No matter how many times you take the same road, there is always something new to discover – and there is no shortage of roads in Barbados! From this information I paint, draw and create images that capture a feeling of the people and their land. As I mentioned before, Barbadians are a proud people. Proud of their home, proud of the land that has made them, educated them and given them a living and a home.

I love colour and, when illustrating, I use bold colours and simple shapes to capture a feeling. It is in this simplicity that the beauty of what I see is reflected. I also paint in acrylics from my photographs, something I only started doing more seriously on my return home, but which brings me great joy and pride. The images in this book show my growth from my sketches, to my illustrations through to my paintings, using my

photographs and sketching from life. Threaded through them is my poem about Bajan Life.

This book is an impression of Barbados through my eyes as an artist and a citizen, which I would like to share with the many visitors and locals who grace these shores so that they can take a taste of Barbados with them wherever they go.

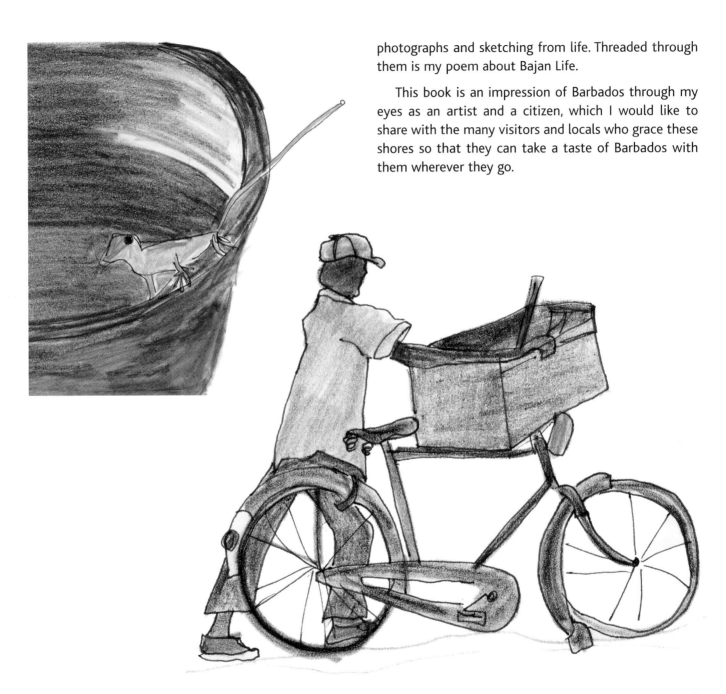

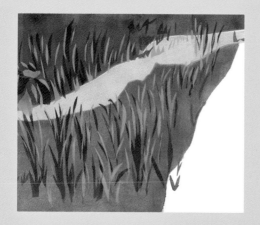

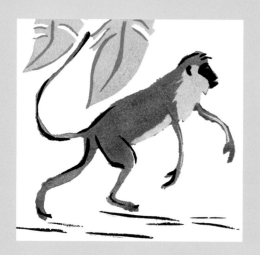

In this land
of winding lanes

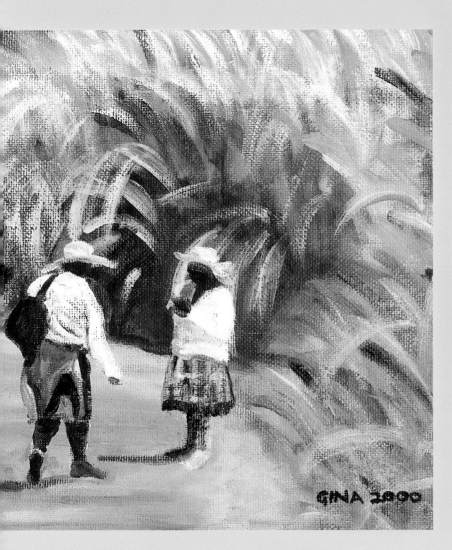

and fields lush
with sugar cane,

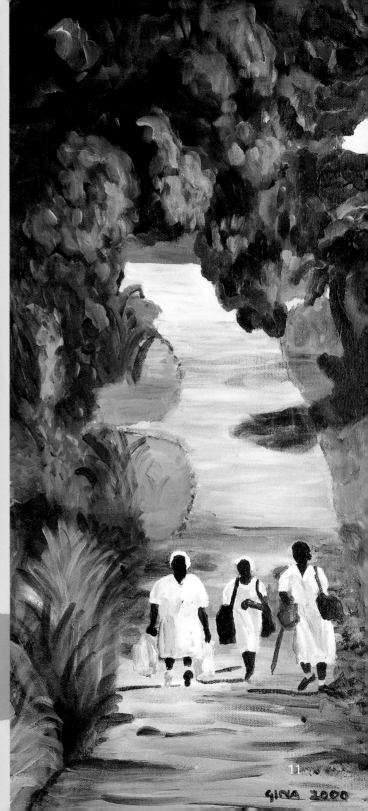

from dawn to dusk
workers toil,
to yield the crop
and work the soil.

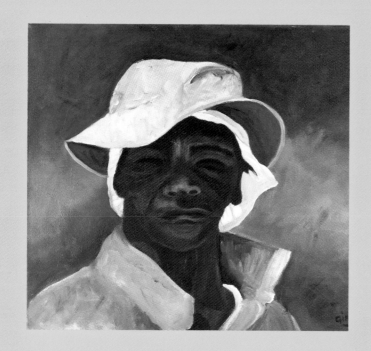

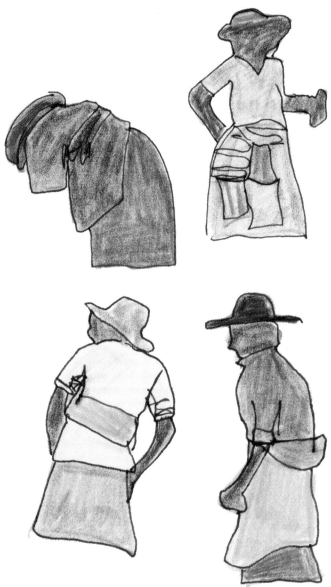

Barbados produces 50,000 tonnes of sugar cane a year and also crops such as cotton, sweet potatoes, eddoes and yams.

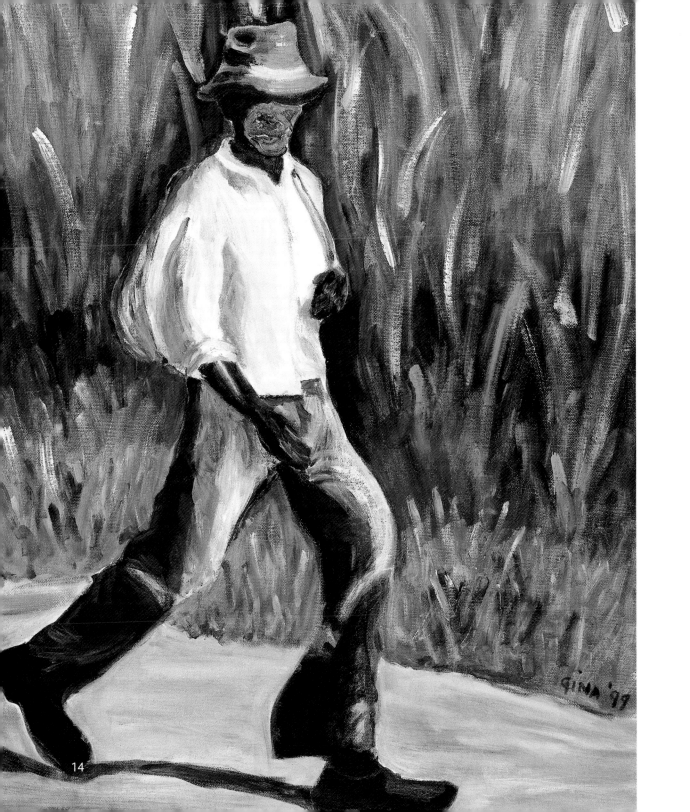

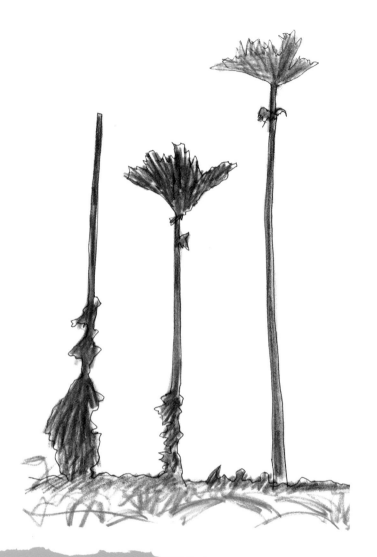

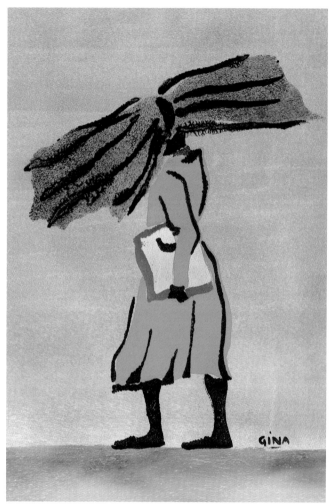

Royal palms salute the sky.
Three hundred years have passed them by.

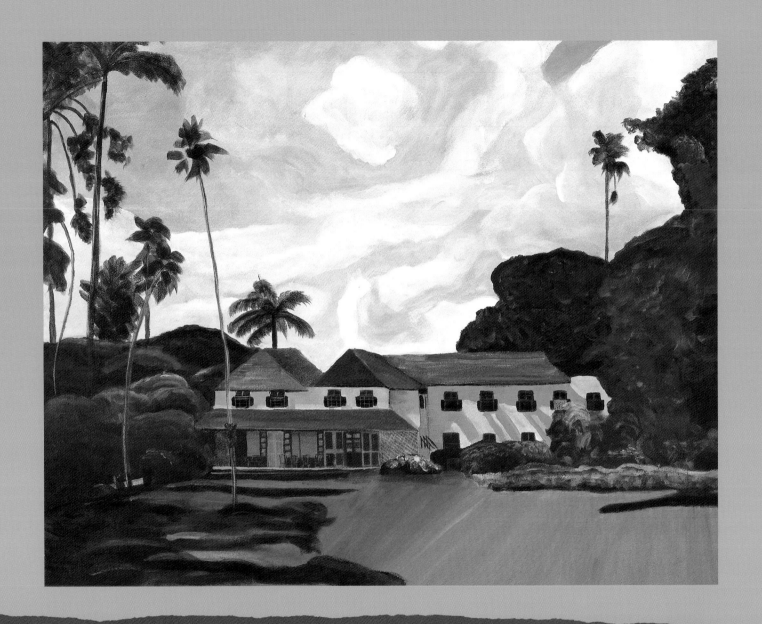

Guarded by palms, Great Houses stand.

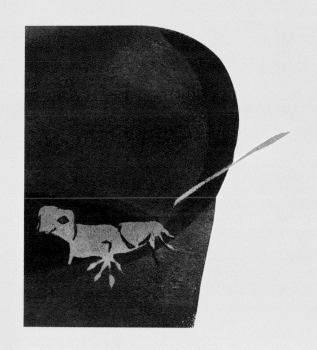

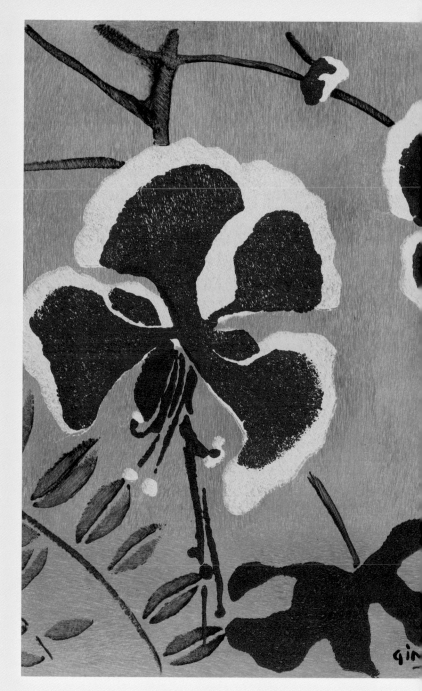

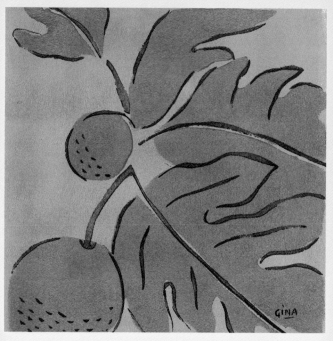

A row of Royal Palms usually indicates an entrance to a Plantation Great House.

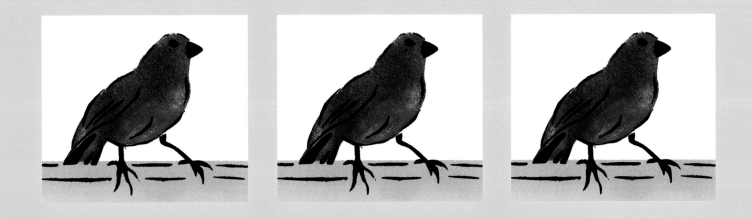

Magnificent gardens dot the land.

A vast variety of colourful flora flourishes all over the island, from the formal gardens of the Great Houses to the natural setting of the Flower Forest.

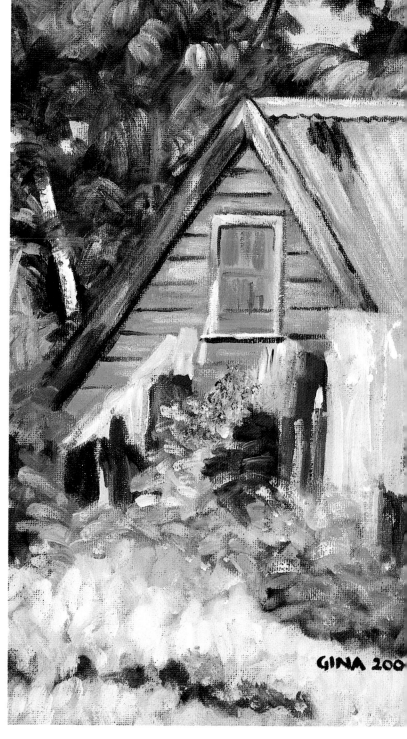

Sleepy villages,
the old time way,
you can still find
them here today.

The local houses called 'Chattel Houses' can be seen dotted all over the island in different shapes, sizes and colours. 'Chattel' means 'moveable possession'.

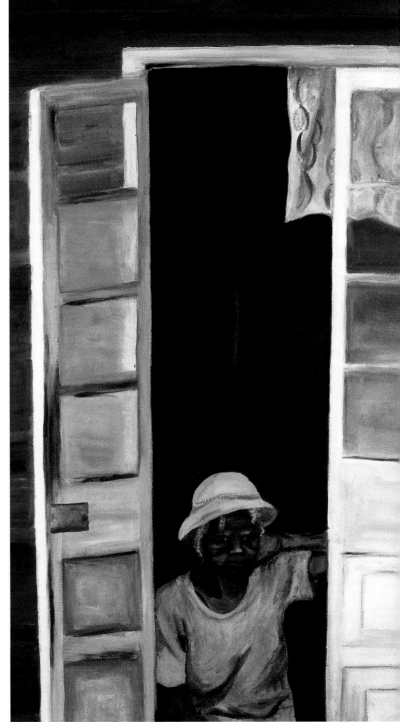

In the country there's a feeling of 'No problem, man', where folks are friendly and will lend a hand.

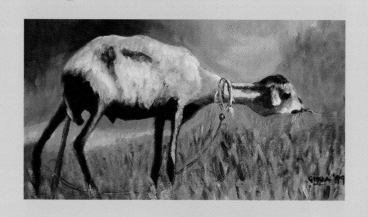

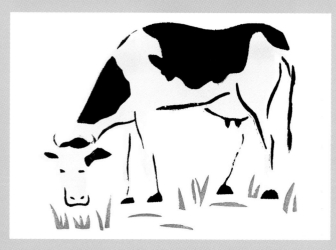

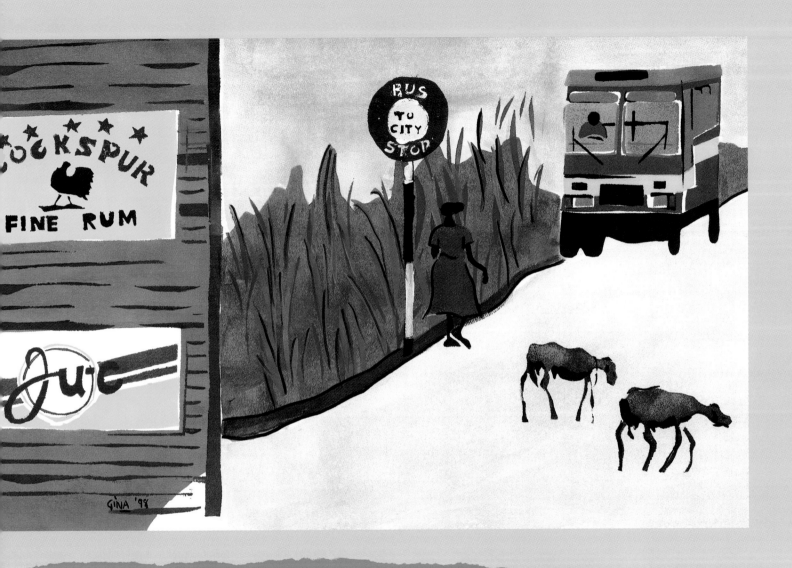

Bus to City. Out of City bus.
The transport used by most of us.

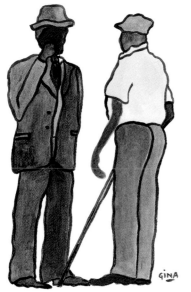

'Morning, Morning'
is the friendly call

24

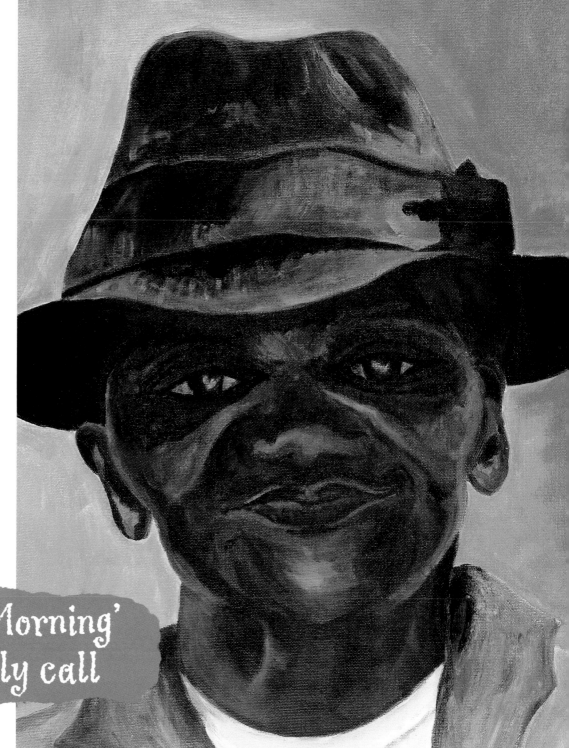

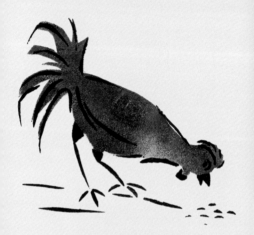

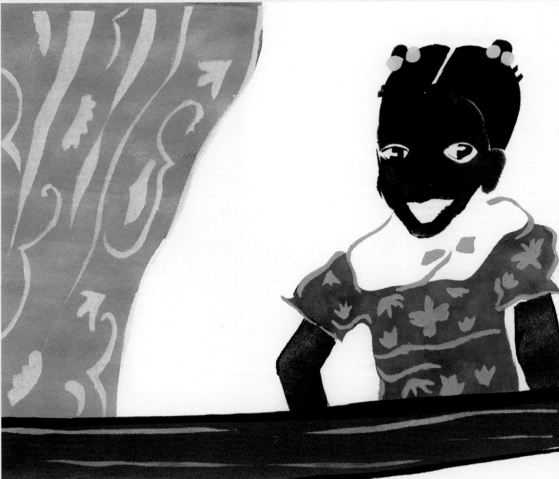

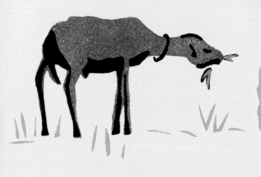

from neighbours, old folk,
one and all.

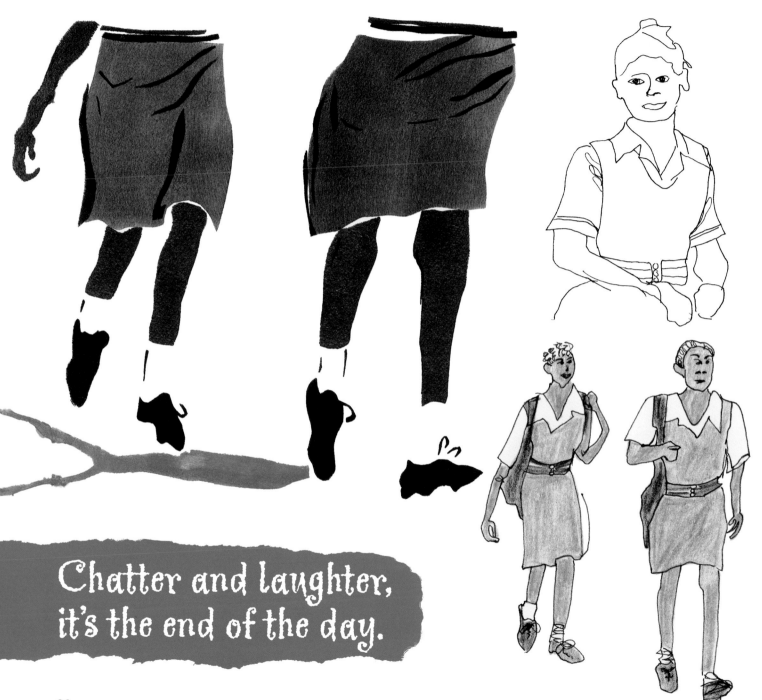

Chatter and laughter,
it's the end of the day.

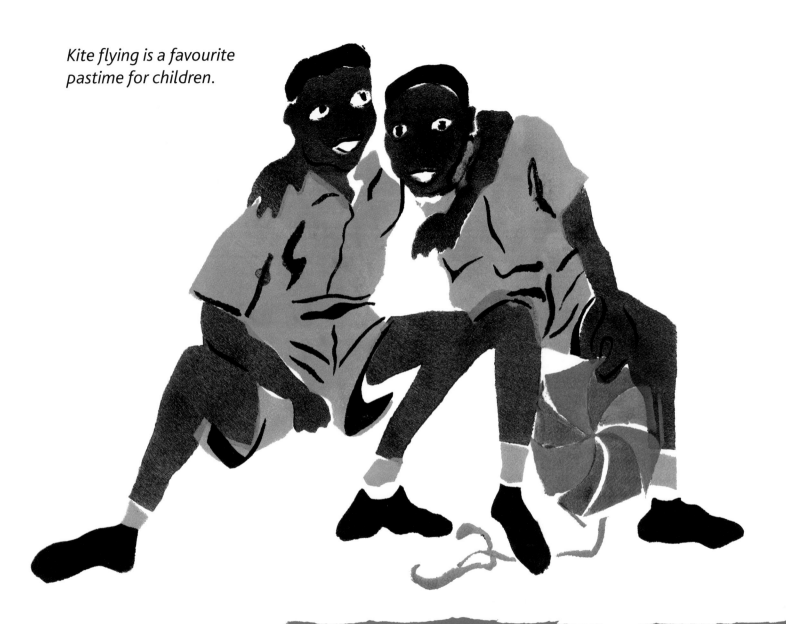

Kite flying is a favourite pastime for children.

School's out – we free to play.

'Church is we ting'

Hints to those who worship God in this Church

1. Be in Time.
2. Go straight into Church.
3. Kneel down on your Knees.
4. Do not look round every time the door opens.
5. Join in all the Prayers, and the Singing, and Amens.
6. Stand up directly the Hymns are given out.
7. Do not whisper to your neighbour.
8. Keep your thoughts fixed.
9. Bow your head at the Most Holy Name of Jesus.
10. Make Almsgiving a regular part of your Worship.

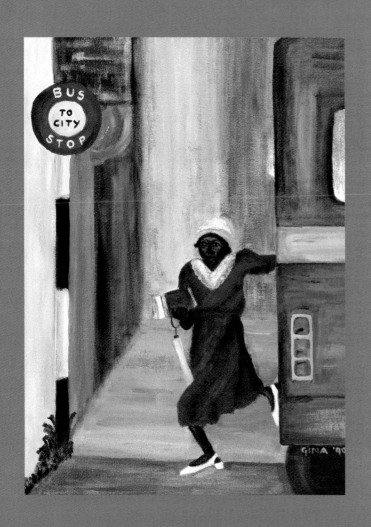

Put on your best frock, hat, shoes and bag.
Raise your voice and sing.

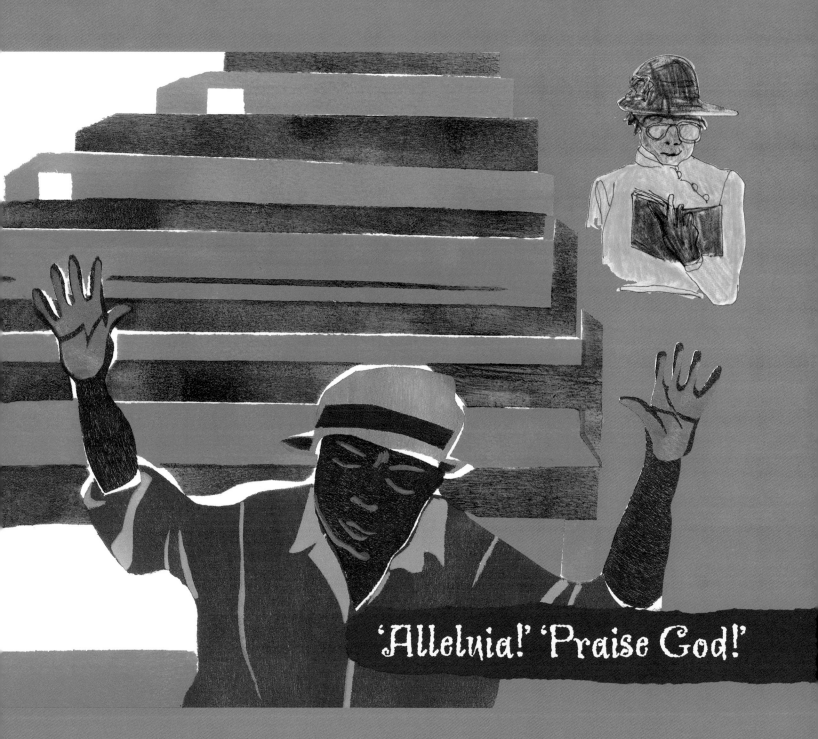

'Alleluia!' 'Praise God!'

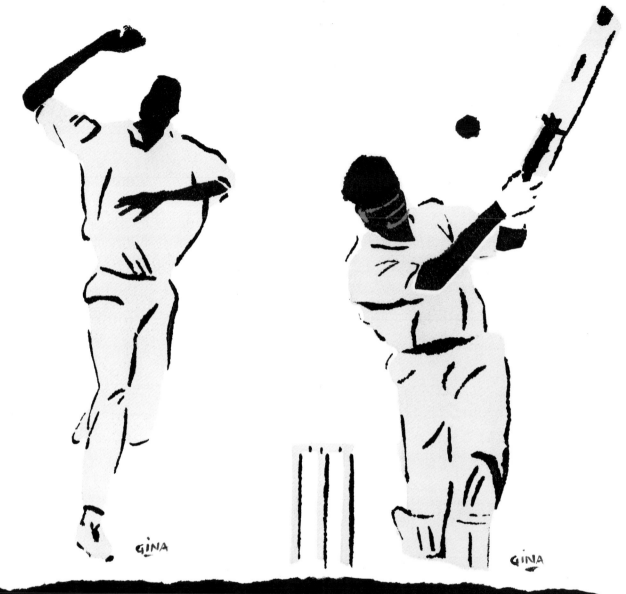

Cricket – the other religion. Following it around the world is part of our tradition.

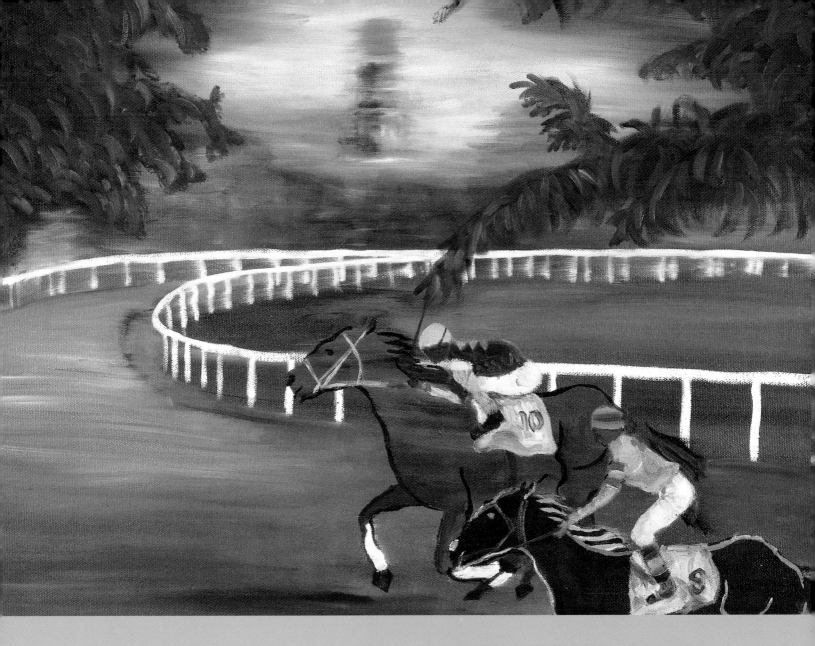

Garrison Savannah – 50 acres surrounded by historic buildings – is best known throughout the Caribbean as a top-class horse-racing track. Horse-racing in Barbados dates back to 1845. With the formation of the Barbados Turf Club in 1905 and the birth of the prestigious Gold Cup race in March 1982, it now draws international acclaim.

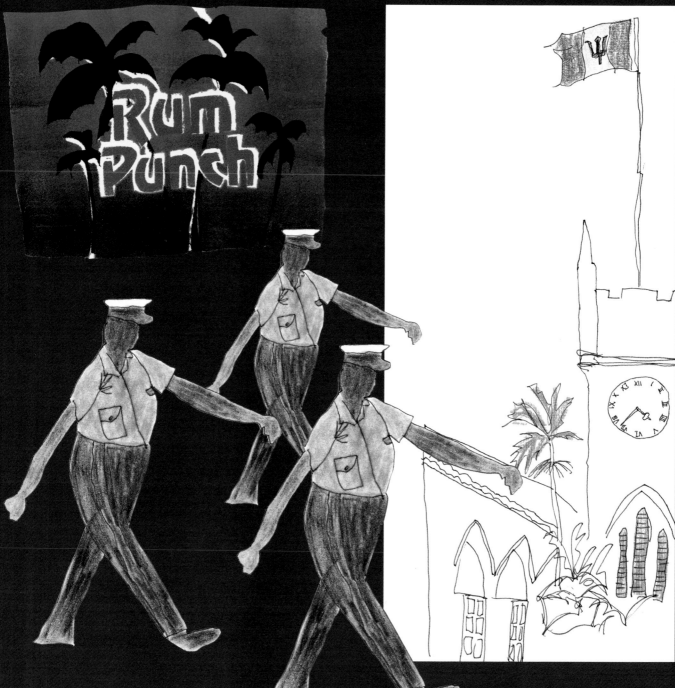

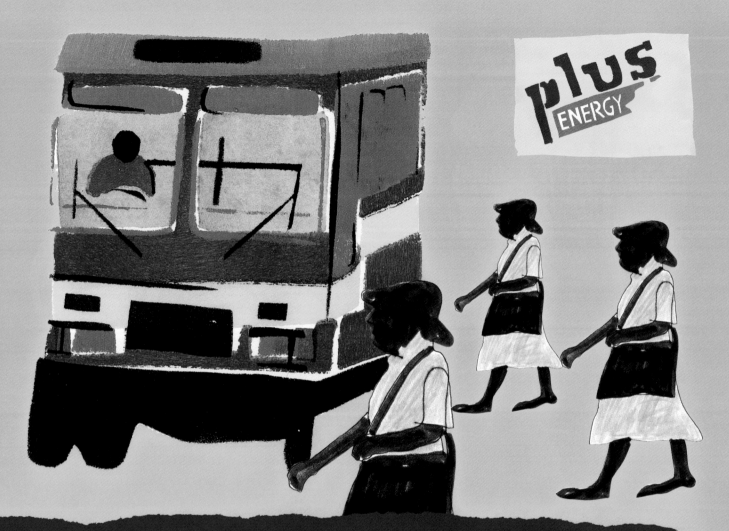

Bridgetown is the centre, bustling and heaving.
People from all directions, coming, leaving.

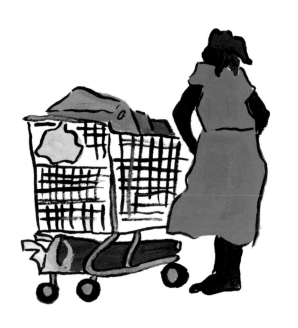

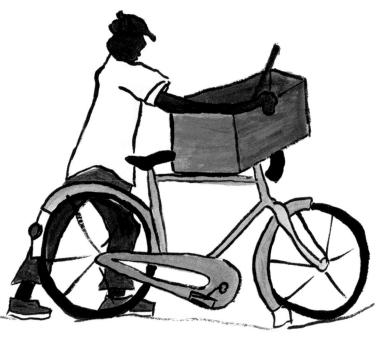

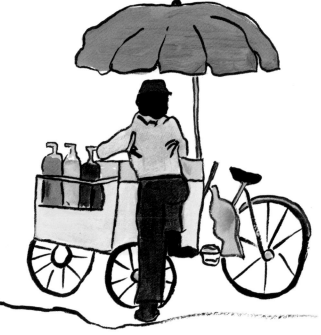

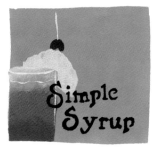

Simple
Syrup

Buying and selling is the business of the day.

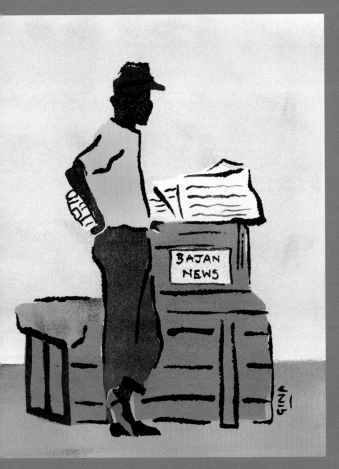

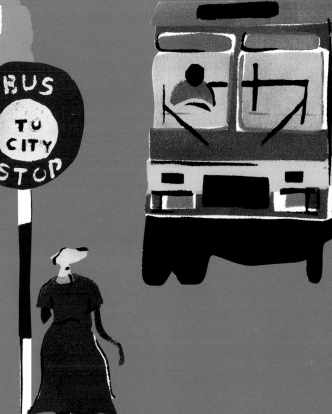

Goods and wares all on display.

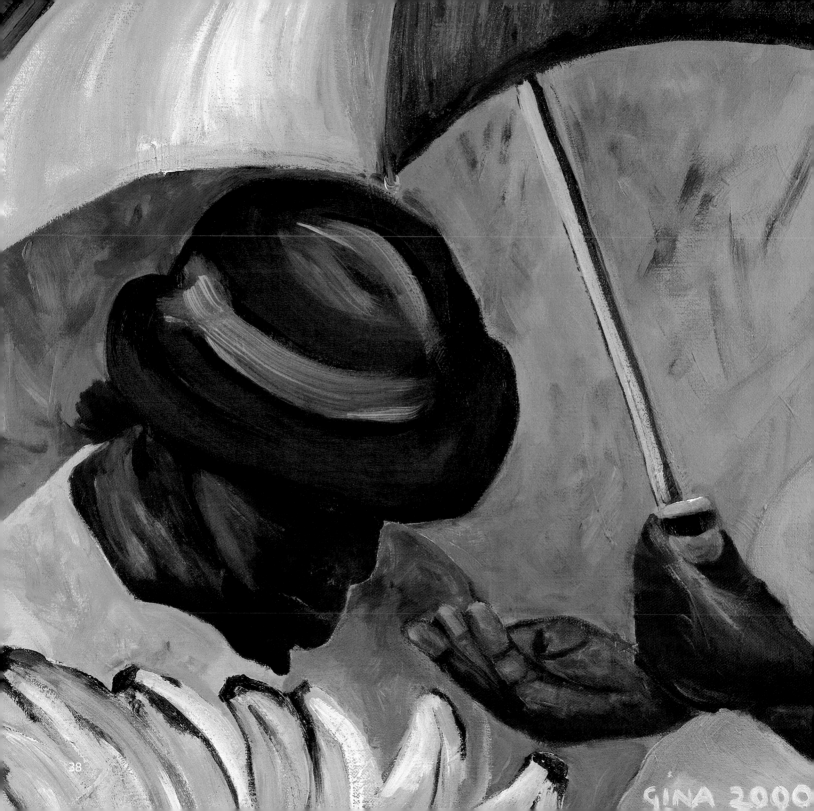

GINA 2000

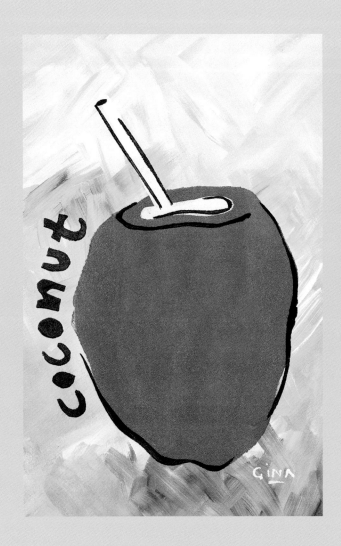

coconut

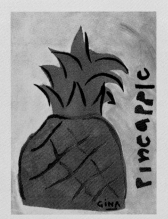

Pineapple

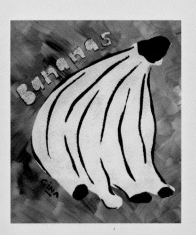

Bananas

In the market hear the hawkers cry,
'Look, just two fuh a dolla, come and buy!'

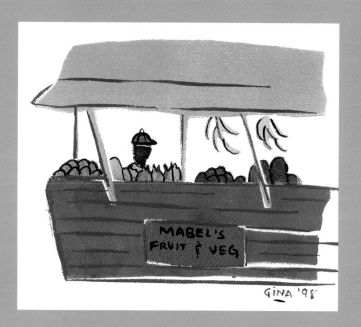

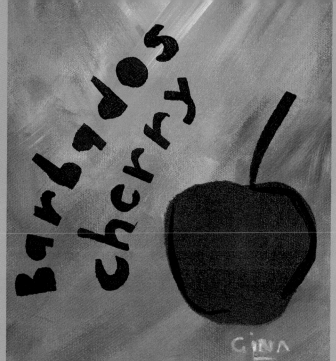

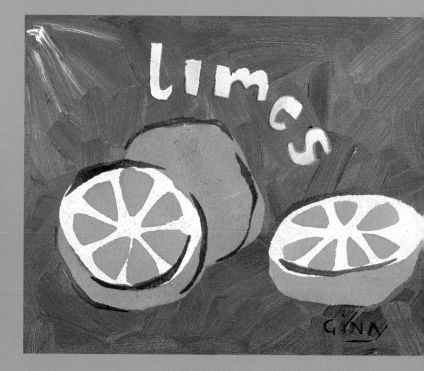

'Plantains, bananas,
mangoes real sweet,
dem is ripe,
dey ready to eat!'

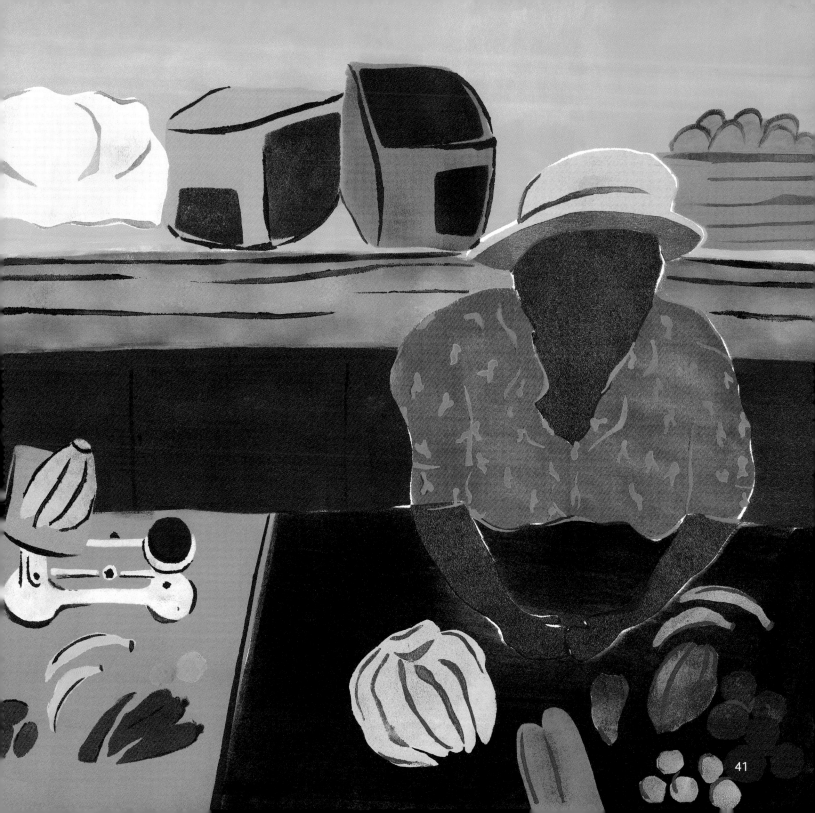
41

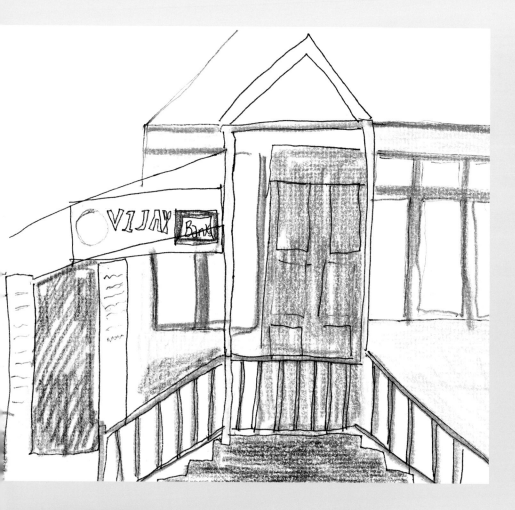

Banks

Old Time Recipe
FALERNUM

When work done
fire a rum
and have some fun!

FIVE STAR
COCKSPUR
FINE RUM

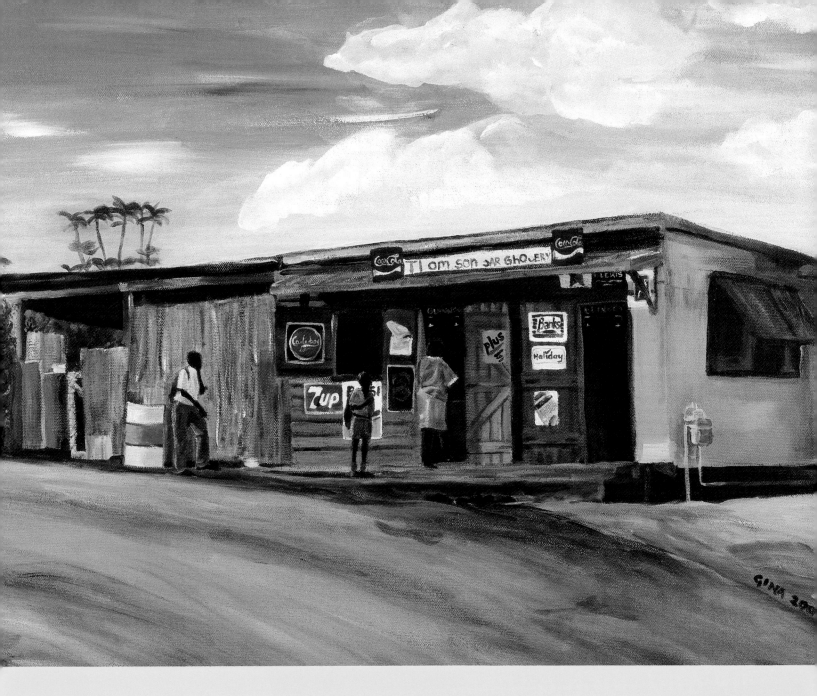

The local rum shop is often frequented by Bajans drinking rum and slamming dominoes.
It is usually decorated by local signs advertising beverages for sale.

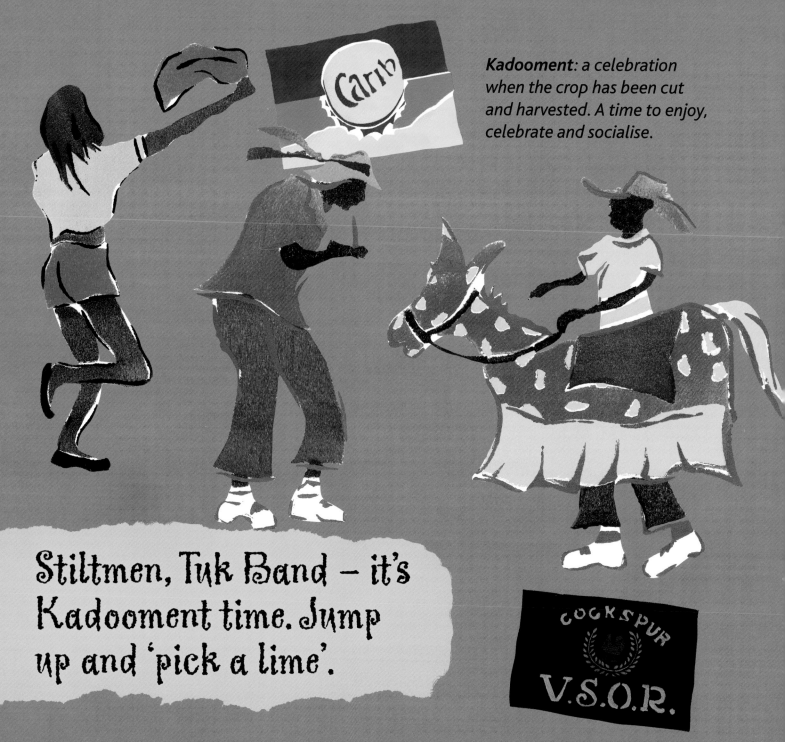

Kadooment: a celebration when the crop has been cut and harvested. A time to enjoy, celebrate and socialise.

Stiltmen, Tuk Band – it's Kadooment time. Jump up and 'pick a lime'.

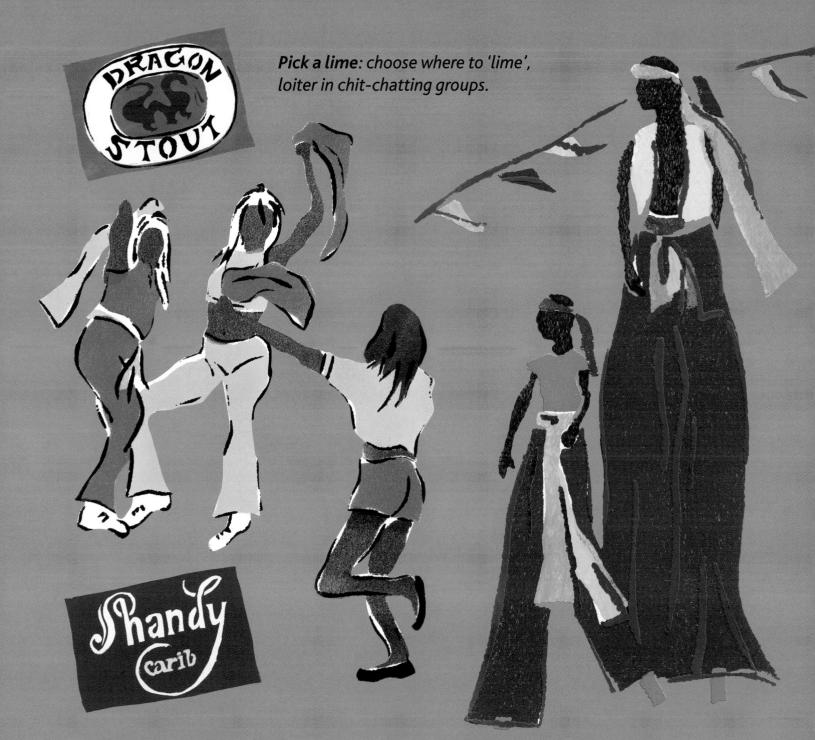

Pick a lime: choose where to 'lime',
loiter in chit-chatting groups.

45

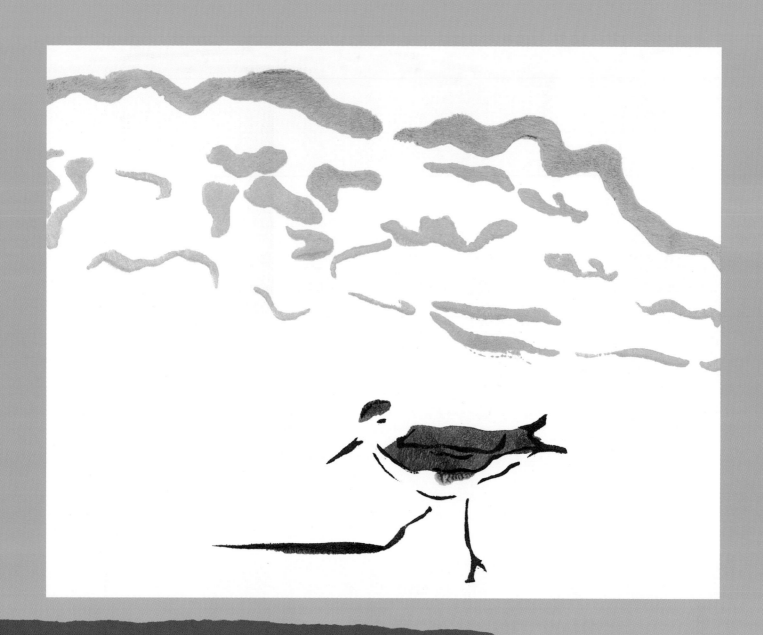

North, South, East and West,

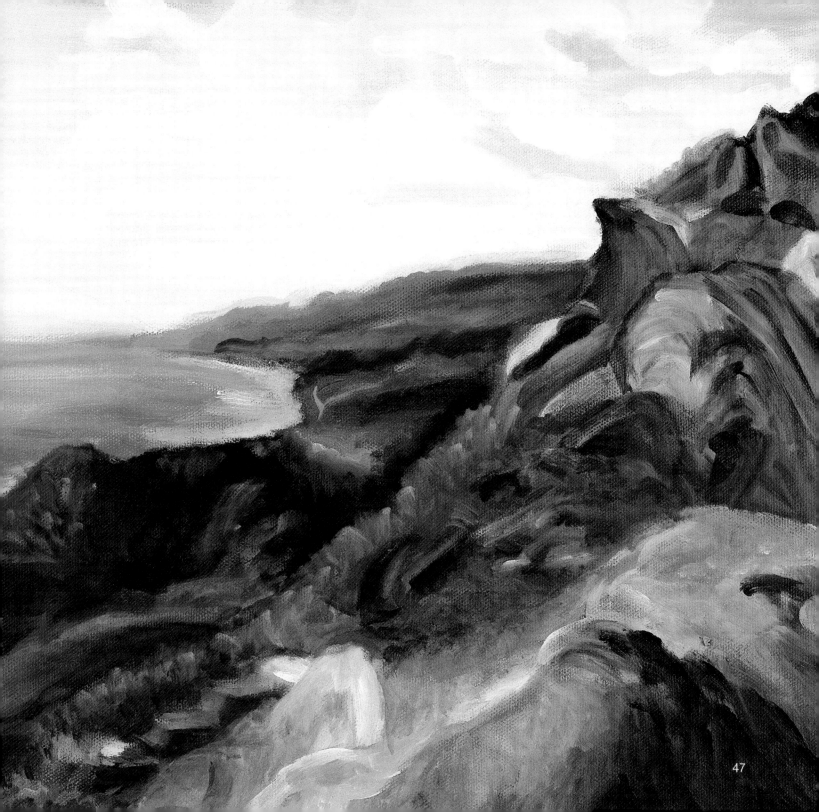

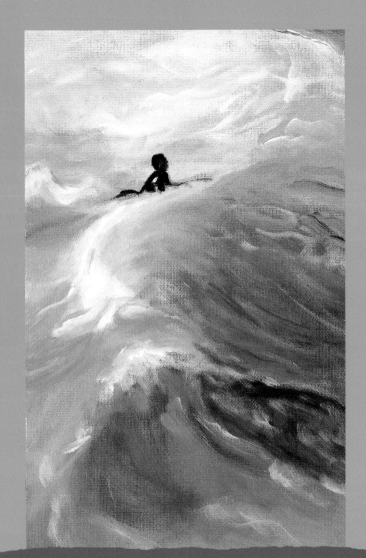

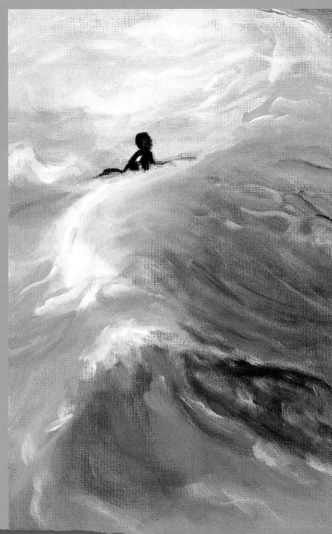

with turquoise waters we are blessed.

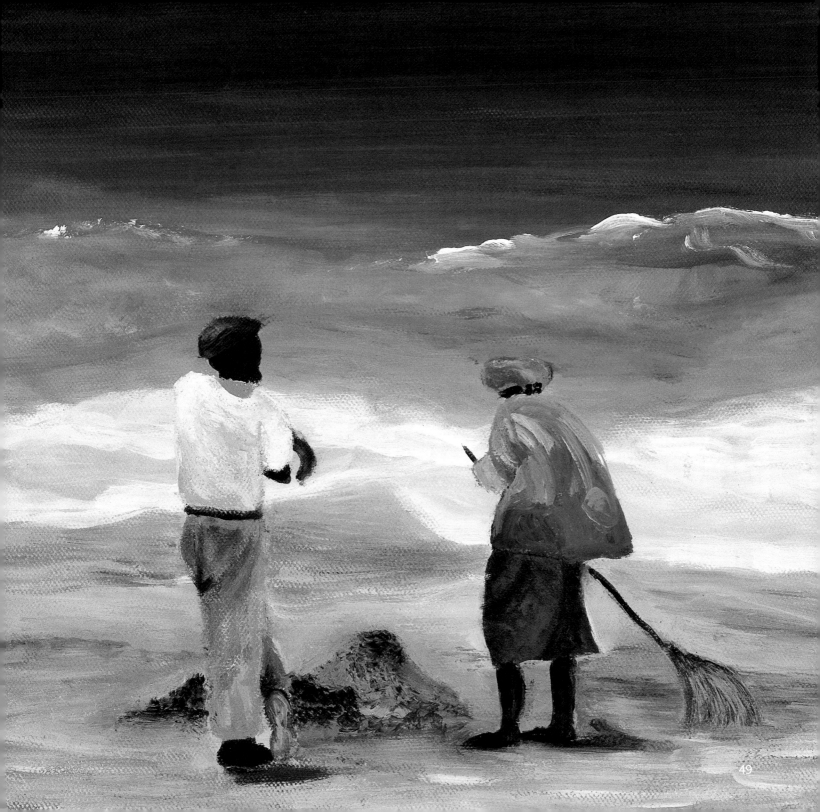

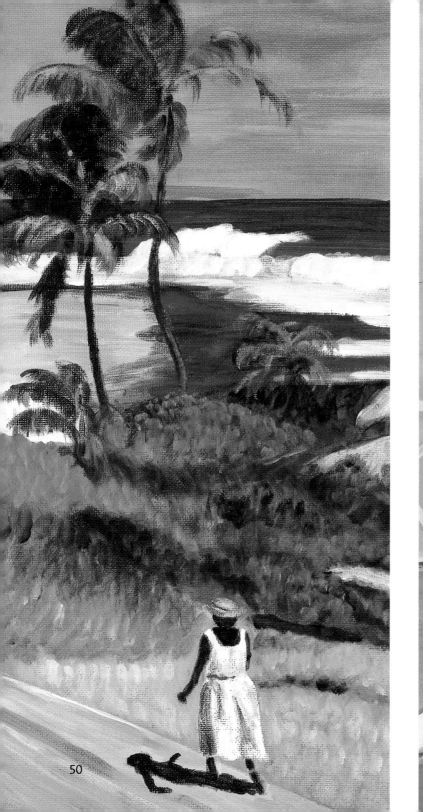

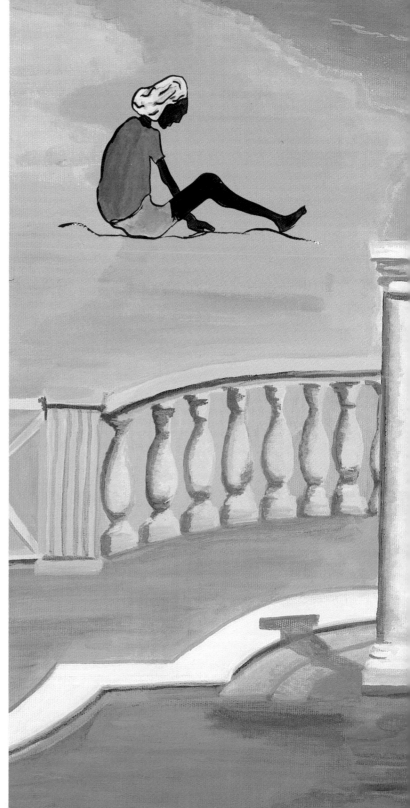

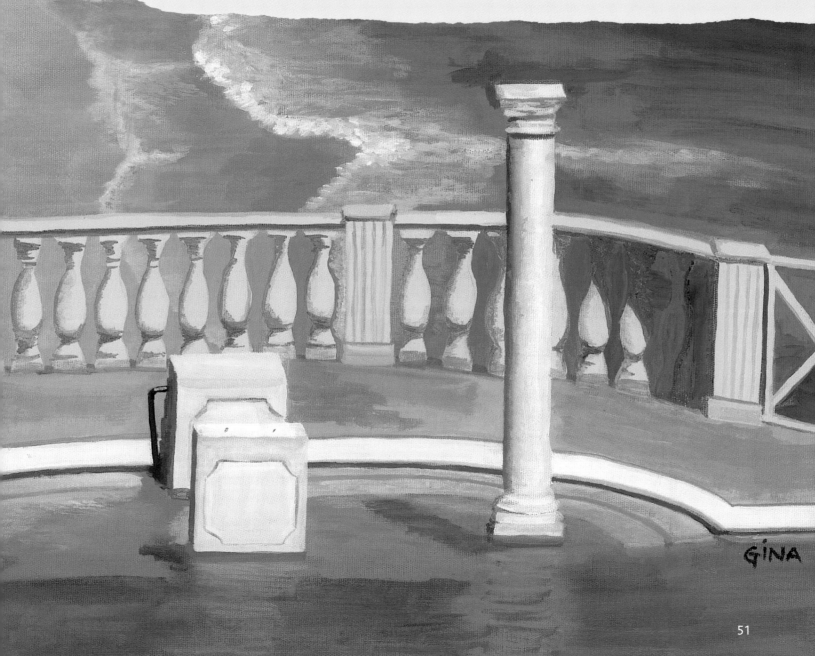

Beautiful beaches surround our shores,

GINA

51

welcoming visitors
and many more.

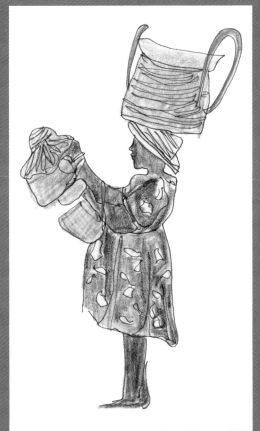

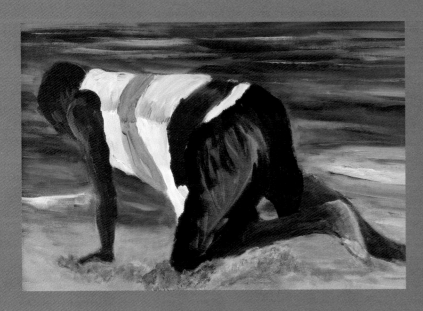

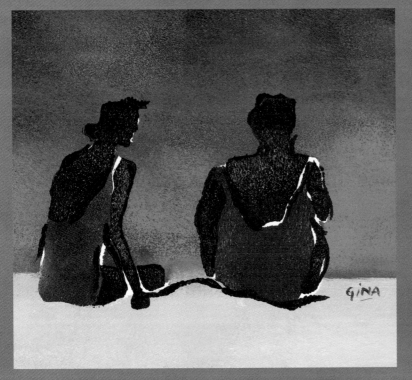

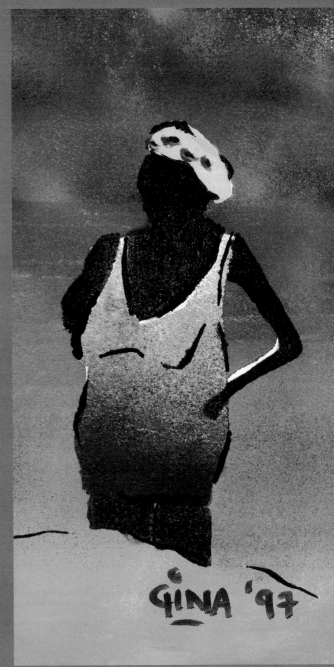

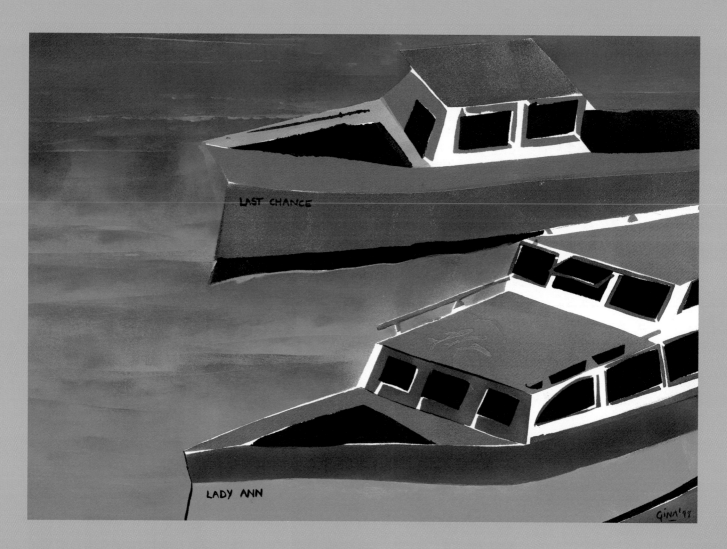

The fishermen in their colourful boats bring in their catch of Flying Fish, Dolphin Fish and Red Snapper.

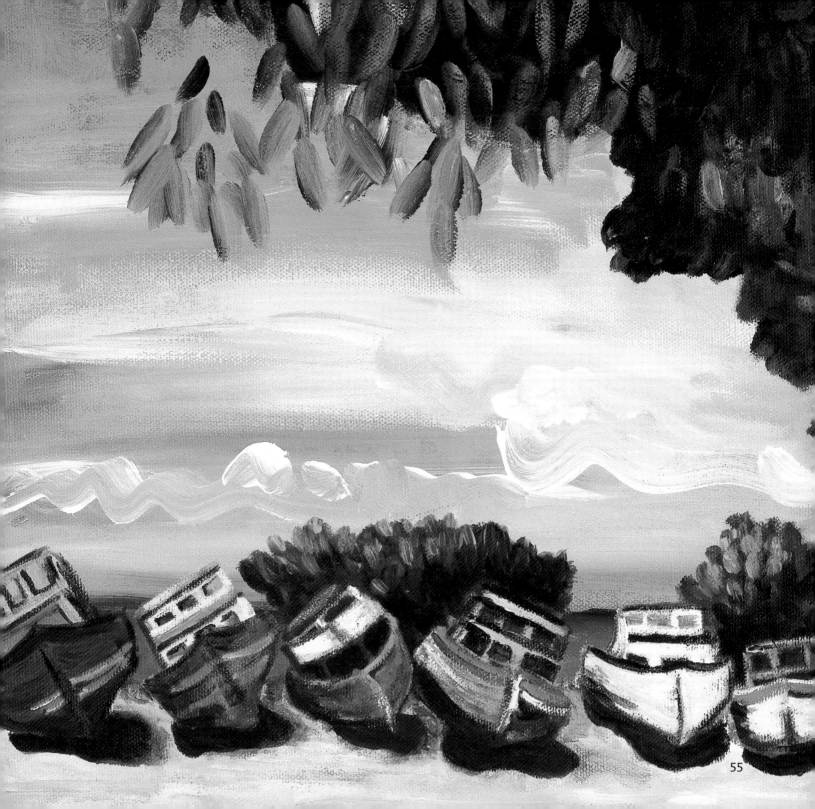

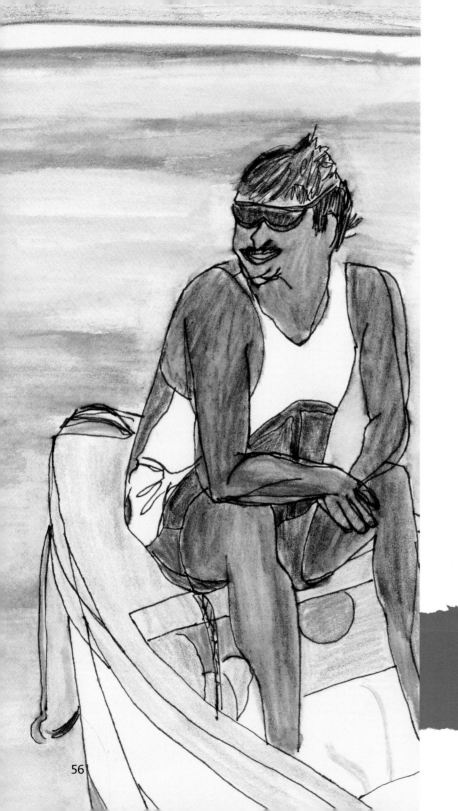

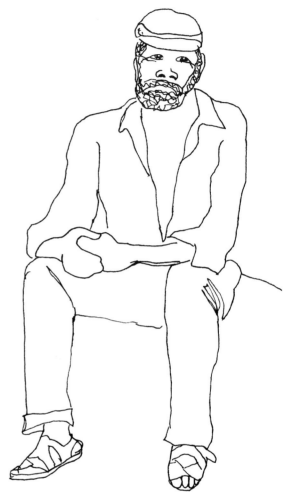

Men of the sea
cast their nets.

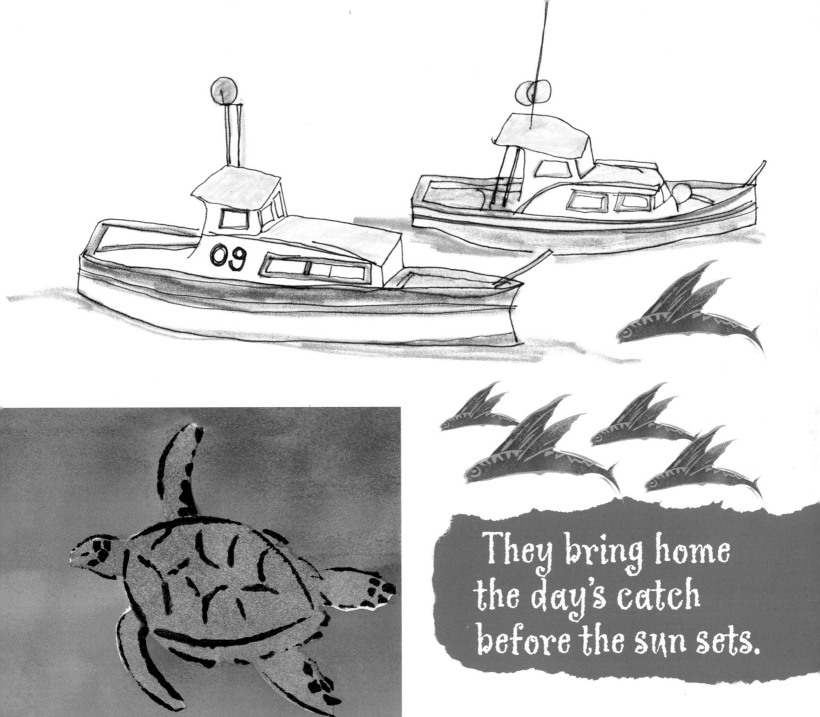

They bring home
the day's catch
before the sun sets.

Turtles that live in these waters are protected.

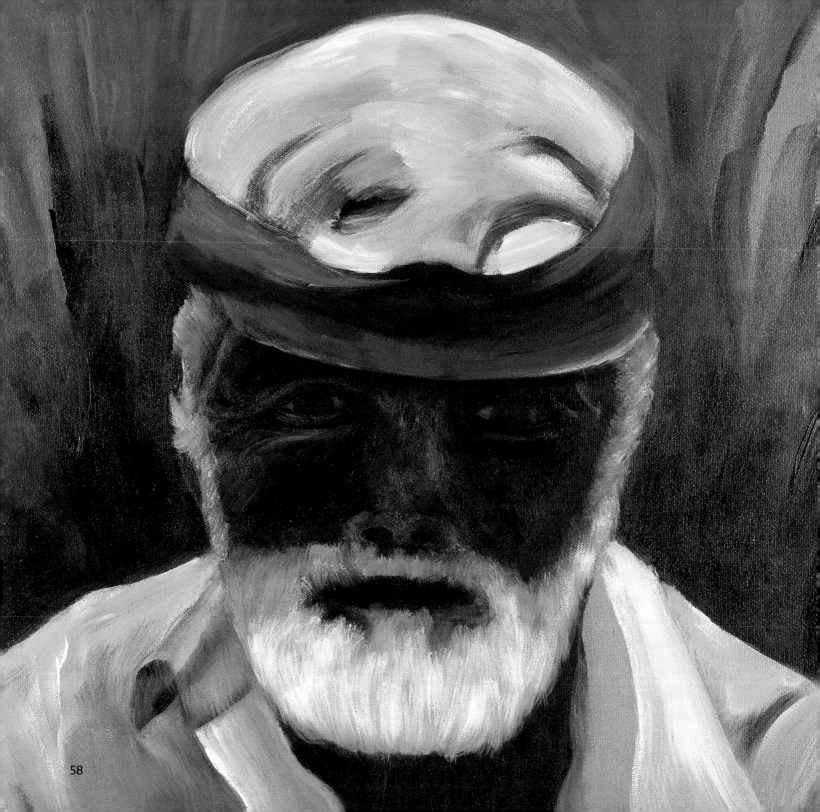

Fried Flying Fish

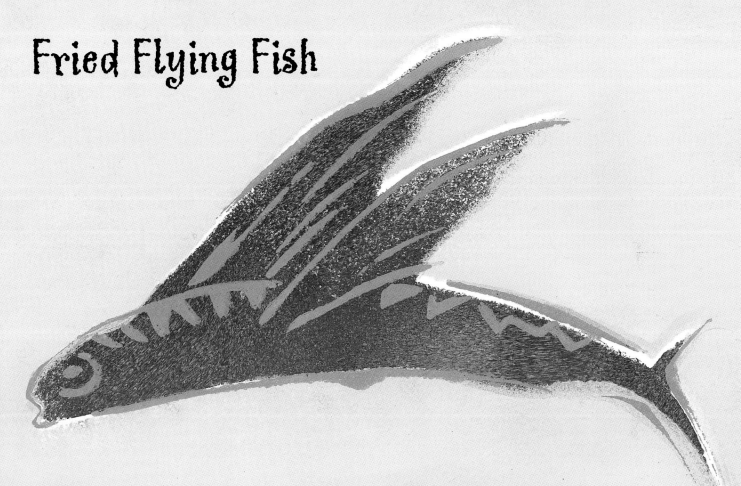

Ingredients

10 boneless Flying Fish
2 limes or lemon juice
1 tbs salt
½ cup water
1 small pack of bread crumbs
2 eggs
¼ cup flour
1 cup milk
Oil
Seasoning (Bajan seasoning ready mixed)

Method

Put the water in a bowl.
Add salt, lime or lemon juice and fish.
Let it marinate for 30 mins.
Rinse and drain for 2 mins.
Season the fish.
Dip in flour.
Dip in batter of milk and eggs.
Cover in bread crumbs.
Fry in hot oil until golden brown.

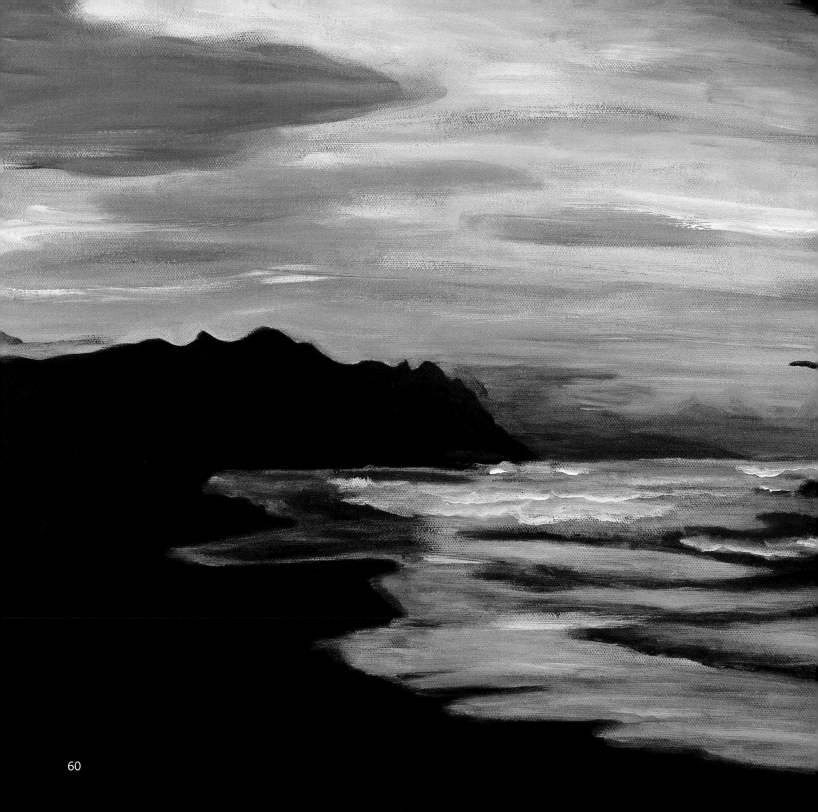

From Coast to Coast I've travelled this land
from green hill top to golden sand.
A magic spell has found its way
into my heart. Forever it shall stay.

About the images in this book

You may like to know more about the images in this book. I've been asked how big the originals are (dimensions are given as height x width), what medium was used, where some of the places are and what influenced me to paint them. So here are some notes for the curious.

Page 3 - Palm Row
Stencil, acrylic on paper, size 13"x 26".

Originally illustrated for my hand-made book, *'I Live Here'*, representing the line in the poem *'a land bathed in gold'*.

Page 4 - Oistins, Christ Church
Acrylic on canvas, size 11"x 14".

A fishing town on the South Coast. When I was a child my mother used to always come here to buy her fresh fish. There are always fishing boats anchored in the bay or pulled up on shore for repairs. And on Friday nights Oistins turns into a hub of activity, with the popular Oistins Fish Fry, where locals and visitors can have a traditional meal with music and dancing.

Page 5 - Map of Barbados
Stencil, acrylic on canvas, 10"x 8".

Barbados is divided into 11 parishes and each one has its own personality. This little gem of an island holds many warm memories for me and has something to offer everyone.

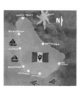

Page 6 - Black Belly Sheep
Sketch, ink, coloured pencil, size 6"x 8".

From my sketch book. Originally sketched as research for my hand-made book, *'I Live*

Here', but was used in my hand-made book, *'We Live Here'*, which represented 10 animals that live in Barbados.

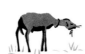

Page 6 - Black Belly Sheep
Stencil, acrylic on paper, size 5½"x 7".

Finished illustration for my book, *'We Live Here'*. Also produced on T-shirts for Gina's Tees.

Page 6 - Black Belly Sheep
Original painting, acrylic on canvas board, size 10"x 14".

Black Belly sheep are indigenous to Barbados. They have such character in their faces I love to draw them. I have painted them on T-shirts, beach wraps and pillow cases.

Page 7 - Man lounging at bus stop
Sketch, ink, coloured pencil, size 6"x 8".

From my sketch book,. *'Research on Barbadian Characters'*.

Page 7 - Saga Man
Sketch, ink, coloured pencil, size 8"x 6".

From my sketch book, *'Research on Barbadian Characters'*.

Page 8 - **Old man**
Sketch, ink, size 6"x 8".

From my sketch book. This person had so much character that I developed him into my stencil illustrative style and then based two works on him. My first painting of this character is shown on page 24.

Page 8 - **Old man**
Stencil, acrylic on paper, size 13"x 17".

This was developed for my hand-made book, *'I Live Here'*, representing the line in the poem *'and friendly people'*.

Page 9 - **Lizard on bowl**
Sketch, ink, coloured pencil, size 6"x 8".

From my sketch book.

Page 9 - **Bicycle man**
Sketch, ink, coloured pencil, size 6"x 8".

From my sketch book, *'Research on Barbadian Characters'*.

Page 10 - **Sugar Cane Road**
Stencil, acrylic on paper, size 13"x 19".

Developed for my hand-made book, *'I Live Here'*, representing the line from the poem *'of winding paths leading through fields of cane'*.

Page 10 - **Monkey**
Stencil, acrylic on paper, size 5¹⁄₂"x 7".

Developed for my hand-made book, *'We Live Here'*. Also produced on T-Shirts for Gina's Tees. A lot of visitors are fascinated by the local monkeys called the Barbadian Green Monkey. They can be spotted all over the island.

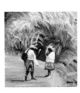

Pages 10-11 - **Workers on their way home**
Acrylic on canvas board, size 8"x 16".

Colleton, St Peter.

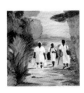

Page 11 - **Three women walking**
Acrylic on canvas, size 30"x 18".

Owned by Mrs Paula Taheri, England.

Page 12 - **Blue lady**
Acrylic on canvas, size 16"x 20".

I met this worker during one of my drives around the island in St Thomas. She was walking across a field and I stopped to ask her to pose for me. She had such personality in her face. My first painting of her sold before I had started to work on this book. For this painting I used a natural palette. Then I painted her with red tones and then finally blue tones. I was experimenting with tones and strong colours.

Pages 12-13 - **Red lady**
Acrylic on canvas, size 18"x 24".

This is the same lady mentioned above, painted in red tones. Owned by Mr & Mrs John Graham, Barbados.

Page 13 - **Four women in field**
Sketch, ink, coloured pencil, size 6"x 8".

From my sketch book

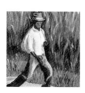

Page 14 - **Man walking canes**
Acrylic on canvas board, size 25"x 19".

I went with a fellow-artist and friend, Vanita Comissiong, to Mrs Ellison's house in Locust Hall and I noticed these characters passing on the street between her home and the cane fields. I love the movement that I captured in my photograph and decided that it had to be captured on canvas as well.

Page 15 - **Royal Palm**
Sketch, ink, coloured pencil, size 8"x 6".

From my sketch book.

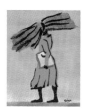

Page 15 - **Lady carrying fodder**
Stencil, acrylic on paper, size 10"x 8".

This was developed from a black and white photograph taken during the 1980s of a lady carrying fodder home, who was walking on the road below my parent's home in Rendezvous Terrace. At that time there were fields of sugar cane across the road from our home, which today no longer exist. I loved her 'go forwards', as some locals call them, but they are better known to the world as 'slippers'.

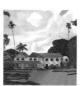

Page 16 - **Brighton Plantation**
Acrylic on canvas, size 20"x 24".

This plantation house dates back to 1652 and is one of the oldest on the island. It has been in the Pile family for generations. Michael Pile is married to my cousin Alison, who is one of my oldest and dearest friends, and they have encouraged and supported me in many ways. This was painted for 'Sweet Bajan Days', but also painted as a present to thank them for their friendship and generosity over the years. It now hangs in its rightful place in Brighton House.

Page 17 - **Croton**
Stencil, acrylic on paper, size 10"x 10".

The series of flowers and plants and fruits was designed for another book entitled *'We Grow Here'*, which has not been completed.

Page 17 - **Heliconia**
(also known as Lobster Claw)
Stencil, acrylic on canvas, size 20"x 10".

Page 17 - **Whistling frog**
Stencil, acrylic on paper, size 5½"x 7".

From the book, *'We Live Here'*. Also produced on T-shirts for Gina's Tees.

Page 18 - **Green lizard**
Stencil, acrylic on paper, size 5½"x 7".

From the book, *'We Live Here'*.

Page 18 - **Pride of Barbados**
Stencil, acrylic on paper, size 10"x 10".

Barbados's national flower.

Page 18 - **Breadfruit**
Stencil, acrylic on paper, size 10"x 10".

Breadfruit is a local staple and can be enjoyed roasted, pickled, boiled or fried.

Page 19 - **Sparrow**
Stencil, acrylic on paper, size 5¹/₂"x 7".
From the book, *'We Live Here'*. The sparrow is one of the common species of birds on the island and they are often seen perched on verandahs or hopping into open kitchens looking for crumbs.

Page 20 - **Pink chattel house**
Sketch, ink, coloured pencil, size 6"x 8".
From my sketch book.

Page 20 - **Pink chattel house on the way down to the East Coast**
Acrylic on canvas board, size 12"x 10".

Page 21 - **Verandah, West Coast**
Ink, sketch, size 6"x 8".
From my sketch book.

Page 21 - **Front of house and gate, Dayrells Road**
Ink, coloured pencil, sketch 6"x 8".
From my sketch book.

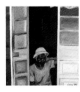

Page 21 - **Lady in doorway, countryside**
Oil on canvas board, size 30"x 20".

Page 22 - **Black Belly Sheep**
Acrylic on canvas board, size 10"x 14".

Page 22 - **Cow**
Stencil, acrylic on paper, size 5¹/₂"x 7".
From the book, *'We Live Here'*.

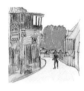

Page 22 - **Speightstown, St Peter**
Ink, coloured pencil, 8"x 6".

From my sketch book. Speightstown is the most northern town on the island and was originally a thriving port. It has retained its old world charm and the harbour is kept alive by the fishing boats.

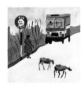

Page 23 - **Bus to city stop**
Stencil, acrylic on paper, size 15"x 25".

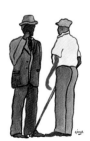

Page 24 - **Old men chatting, Early Sunday Morning, Bridgetown**
Acrylic on paper, size 10"x 8".

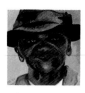

Page 24 - Old man
Acrylic on canvas board, size 20"x16".
This was my first portrait. I have kept this for my personal collection.

Page 25 - Pig
Stencil, acrylic on paper, 5½"x7".
From the book, *'We Live Here'.*

Page 25 - Fowl cock
Stencil, acrylic on paper, size 5½"x7".
From the book, 'We Live Here'.

Page 25 - Black Belly Sheep
Stencil, acrylic on paper, 5½"x7".
From the book, *'We Live Here'.*

Page 25 - Girl at window
Stencil, acrylic on paper, size 13"x19".
Developed for my book, *'I Live Here'*, representing the line from the poem, *'of warm smiles'*. This image was of a young girl called Samantha. I knew her Grandmother personally and she grew close to our family.

Page 26 - School girls
Stencil, acrylic on paper, size 13"x19".
Developed for my book, *'I Live Here'*, representing the line from the poem, *'the echoing footsteps of running school children'*. This uniform is a Queen's College uniform, a school where I received my secondary education in Barbados and of which I have fond memories.

Page 26 - School girl at window
Ink, sketch, 8"x6".
From my sketch book.

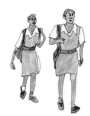

Page 26 - School girls
Ink, coloured pencil, size 8"x6".
From my sketch book.

Page 27 - School boys
Stencil, acrylic on paper, size 13"x19".
Developed for my book *'I Live Here'*, representing the line from the poem, *'as laughter and chatter fill the air'*.

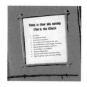

Pages 28-29 - Church door
Stencil, acrylic on paper, size 13"x19".
Developed for my book *'I Live Here'*, representing the line from the poem *'of voices rejoicing at Sunday Mass'*. This sign was taken from a church door in Christ Church. I was attending a local wedding and was fascinated by the words. It is very reflective of how serious Barbadians are about their religion.

Page 30 - Sunday *stop*
Acrylic on canvas board, size 20"x16".
This was my first painting that I did in Indrani Whittingham's classes, *'The Newcomers'*. I continue to participate in the group as it commits me to a painting schedule in an ideal environment. Indrani and my classmates have given me much encouragement and guidance and to all of

them I owe my thanks, for without them I know that I would still be thinking and not doing. This is part of my personal collection.

Page 30-31 - Praising God
Stencil, acrylic on paper, size 13"x19".

Developed for my book, *'I Live Here'*, representing the line in the poem, *'Praising God, Alleluiah'*.

Page 31 - Church singer
Ink, coloured pencil, size 6"x8".

From my sketch book, *'Research on Barbadian Characters'*.

Page 32 - Bowler, Curtly Ambrose
Stencil, acrylic on paper, size 10"x8".

Page 32 - Batsman, Philo Wallace
Stencil, acrylic on paper, size 10"x8".

Page 33 - Horse-racing at Garrison Savannah
Acrylic on canvas, size 16"x20".

Developed for this book. The jockey No 8 in yellow and blue was painted from a picture of Jonathan Jones, who is one of Barbados's top jockeys, after winning the Sandy Lane Gold Cup 2002.

Page 34 - Rum Punch sign
Stencil, acrylic on paper, size 8"x11".

I produced a book called *'Bajan Signs'* for my end of year Degree show. This is one of ten images.

Page 34 - Policeman
Ink, coloured pencil, size 8"x6".

From my sketch book, *'Research on Barbadian Characters'*.

Page 34 - Parliament buildings
Sketch, coloured pencil, size 8"x6".

From my sketch book.

Page 35 - Bus
Stencil, acrylic on paper, size 7"x6".

Page 35 - Plus sign
Stencil, acrylic on paper, size 8"x11".

From my book, *'Bajan Signs'*.

Page 35 - **Lady walking**
Ink, coloured pencil, sketch, size 8"x6".
From my sketch book.

Page 36 - **Hawker**
Ink, acrylic on paper, size 8"x11".
This is from my book *'Bajans'* which features ten images of Bajan characters.

Page 36 - **Snow-cone man selling shave-ice**
Ink, acrylic on paper, size 8"x11".
From my book, *'Bajans'*.

Page 36 - **Simple Syrup sign**
Stencil, acrylic on paper, size 8"x11".
From my book, *'Bajan Signs'*.

Page 36 - **Bicycle man**
Ink, acrylic on paper, size 8"x11".
From my book *'Bajans'*.

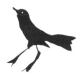

Page 36 - **Black bird**
Ink, sketch, size 6"x8".
From my sketch book.

Page 37 - **Newspaperman, Bridgetown**
Stencil, acrylic on paper, size 10"x8".

Page 37 - **Bus stop**
Stencil, acrylic on paper, size 12"x12".

Page 38 - **Banana seller, Swan Street**
Acrylic on canvas, size 18"x24".

Page 39 - **Coconut**
Stencil, acrylic on canvas, size 14"x11".

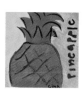

Page 39 - **Pineapple**
Stencil, acrylic on canvas, size 10"x8".

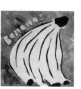

Page 39 - **Bananas**
Stencil, acrylic on canvas, size 12"x12".

Page 39 - **Hawker stand**
Ink, coloured pencil, sketch, size 6"x 8".
From my sketch book.

Page 40 - **Mabel's Fruit and Veg**
Stencil, acrylic on paper, size 8"x 10".

Page 40 - **Barbados cherry**
Stencil, acrylic on canvas, size 10"x 8".

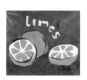

Page 40 - **Limes**
Stencil, acrylic on canvas, size 8"x 10".

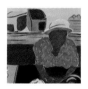

Page 41 - **Market place trader**
Stencil, acrylic on paper, size 21³/₄"x 25¹/₂"

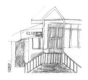

Page 42 - **Vijay's Bar, Bay Street**
Ink, coloured pencil, sketch, size 6"x 8".
From my sketch book.

Page 42 - **Cockspur rum sign**
Stencil, acrylic on paper, size 8"x 11".
From my book, *'Bajan Signs'.*

Page 42 - **Banks sign**
Stencil, acrylic on paper, size 8"x 11".
From my book, *'Bajan Signs'.*

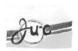

Page 42 - **Falernum sign**
Stencil, acrylic on paper, size 8"x 11".
From my book, *'Bajan Signs'.*

Page 42 - **Ju-c sign**
Stencil, acrylic on paper, size 8"x 11".
From my book, *'Bajan Signs'.*

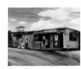

Page 43 - **Rum Shop on the way to Martin's Bay**
Acrylic on canvas, size 20"x 24".
There are many rum shops dotted all over the island, each with its own distinctive personality.

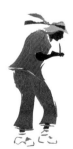

Page 44 - **Tuk Band**
Stencil, acrylic on paper, size 8"x 10".
Also produced on canvas. Uniquely Barbadian. It is the classic folklore band of Barbados, with a bass drum, snare drum, penny whistle and triangle. Often accompanied by dancing characters such as the 'donkey man'. Whenever I go to any of the festivals this little band is always livening up the atmosphere.

Page 44 - **Carib sign**
Stencil, acrylic on paper, size 8"x 11".
From my book, *'Bajan Signs'*.

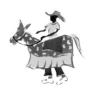

Page 44 - **Tuk Band**
Stencil, acrylic on paper, size 8"x 10".
Also produced on canvas.

Page 44 - **Cockspur VSOR sign**
Stencil, acrylic on paper, size 8"x 11".
From my book, *'Bajan Signs'*.

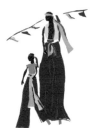

Page 45 - **Stilt Men**
Stencil, acrylic on paper, size 10"x 6", also produced on 12"x 6" canvas.

Page 45 - **Shandy sign**
Stencil, acrylic on paper, size 8"x 11".
From my book, *'Bajan Signs'*.

Page 45 - **Dragon Stout sign**
Stencil, acrylic on paper, size 8"x 11".
From my book, *'Bajan Signs'*.

Page 45 - **Jump Up**
Stencil, acrylic on paper, size 10"x 10".

Page 46 - **Sandpiper Bird**
Stencil, acrylic on paper, size 13"x 19".
Developed for my book, *'I Live Here'*, representing the line from the poem, *'As these images float through my mind, I can feel the water lapping at my feet.'*

Page 47 - **Chalky Mount**
Acrylic on canvas, size 12"x 16".

Page 48 - **The Crane Surfer**
Acrylic on canvas board, size 16"x 8".
This is one of my favourites and is also part of my personal collection.

Page 49 - **Beach Sweepers**
Acrylic on canvas, size 10"x 14".
This prize-winning painting is part of my personal collection.

Page 50 - **Lady walking Cattlewash**
Acrylic on canvas board, size 16"x 12".

Pages 50-51 - **View from 'The Crane' Hotel**
Acrylic on canvas board, size 17¹/₂"x 24".
This was my first commissioned painting. It is owned by Philippa Ryan, who became a dear friend of mine, and it proudly hangs in her home in England. Philippa saw a painting that I had done for my brother and

immediately commissioned me to do this of the Crane Beach, with the view from The Crane Hotel. It is one of her favourite spots, and mine, on the island. This painting was produced in England in my basement flat in Victoria.

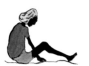

Page 50 (inset) - **Girl on beach**
Ink, acrylic on paper, size 8"x 11".
From my book, *'Bajans'*.

Page 52 - **Tourists**
Acrylic on paper, size 13"x 19".
Developed for my book, *'I Live Here'*, representing the line from the poem, *'leading to a sea of blue.'*

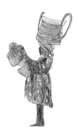

Page 52 - **Bag seller**
Ink, coloured pencil, sketch, size 8"x 6".
From my sketch book, *'Research on Barbadian Characters'*.

Page 52 - **Sunbather**
Acrylic on paper, size 8"x 11".
From my book, *'Bajans'*.

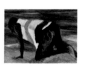

Page 53 - **Boy playing**
Acrylic on canvas board, size 18"x 25".

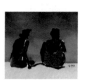

Page 53 - **Women chatting**
Stencil, acrylic on paper, size 5"x 7"
Developed from my book, *'Bajans'*.

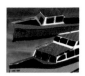

Page 53 - **Lady in sea**
Stencil, acrylic on paper, size 8"x 6"
Developed from my book, *'Bajans'*

Page 54 - **Fishing boats**
Acrylic on paper, size 18"x 24".
Developed from my book, *'I Live Here'*, representing the line from the poem, *'the call of the fisherman, "flying fish five fuh a dolla".'*

Page 54 - **Fishing boat**
Ink, coloured pencil, sketch, size 6"x 8".
From my sketch book

Page 55 - **Oistins**
Acrylic on canvas, size 11"x 14".

Page 56 - **Fisherman in boat**
Ink, coloured pencil, sketch, size 8"x 6".
From my sketch book. This was a sketch of a friend of mine, Brian Fernandes, who is an avid fisherman.

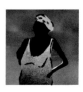

Page 56 - **Man sitting**
Ink, sketch, size 8"x 6".
From my sketch book.

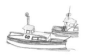

Page 57 - **Fishing boats**
Ink, coloured pencil, sketch, size 6"x 8".
From my sketch book.

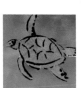

Page 57 - **Turtle**
Stencil, acrylic on paper, size 5½"x 7".
From the book, *'We Live Here'*.

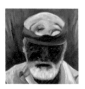

Page 58 - **Blue man**
Acrylic on canvas, size 18"x 24".
This is in safe keeping for my brother-in-law Jan Paul van Driel as a guarantee, a personal treaty between us.

Page 59 - **Flying fish**
Stencil, acrylic on paper, size 5½"x 7".
From the book, *'We Live Here'*. This recipe was given to me by Ophelia Julien – the same person whose daughter, Samantha, I illustrated on page 27. She always cooked the best flying fish and still continues to do so.

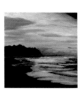

Page 60 - **After the storm, sunset at Cattlewash**
Acrylic on canvas, size 16"x 20".
Owned by Gregory Pitcher, Barbados – given 'with love'. This was painted from a photograph for which I won a NIFCA (National Independence Festival of Creative Arts) award in 1989. The photograph was taken after a hurricane had just passed North of the island.

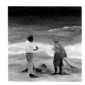

Front Cover - **Beach Sweepers**
Acrylic on canvas, size 10"x 14".
Also viewed on page 50.

I would also like to mention here that the title for this book took a while in coming. Between myself and Nick Gillard of Macmillan Caribbean, who has been very supportive throughout this whole project, many titles were born, but it was my cousin Penny Wight in conversation who just said, 'You need a title that reflects something of Barbados, like, you know, when the Bajans say "That is sweet fuh days" (which means that whatever they are describing is wonderful, delightful, delicious etc)'. So she said, 'Why not Sweet Bajan Days?' And so the title was born and is very appropriate because Barbados is Sweet for Days. Thanks, Penny, for solving that long-debated issue and thanks, Nick, for being so patient.

End Pages - **Smokey Sunset**
Oil on canvas, size 20"x 24".
I usually paint in acrylics but with this particular painting, to capture that wispy smoky feeling, I started in acrylics and finished in oils. This picture was taken on the South Coast. I was driving along one evening, heading home, and there was this beautiful sunset like I had never seen before. I find that taking pictures of sunsets can be sometimes quite 'cliché', so whenever I see an unusual sunset I think, 'Here, this is something different' and hence this painting was born and I thought it would be perfect for my end pages. Owned by Terry & Tony Foster, Barbados, a gift to my parents.

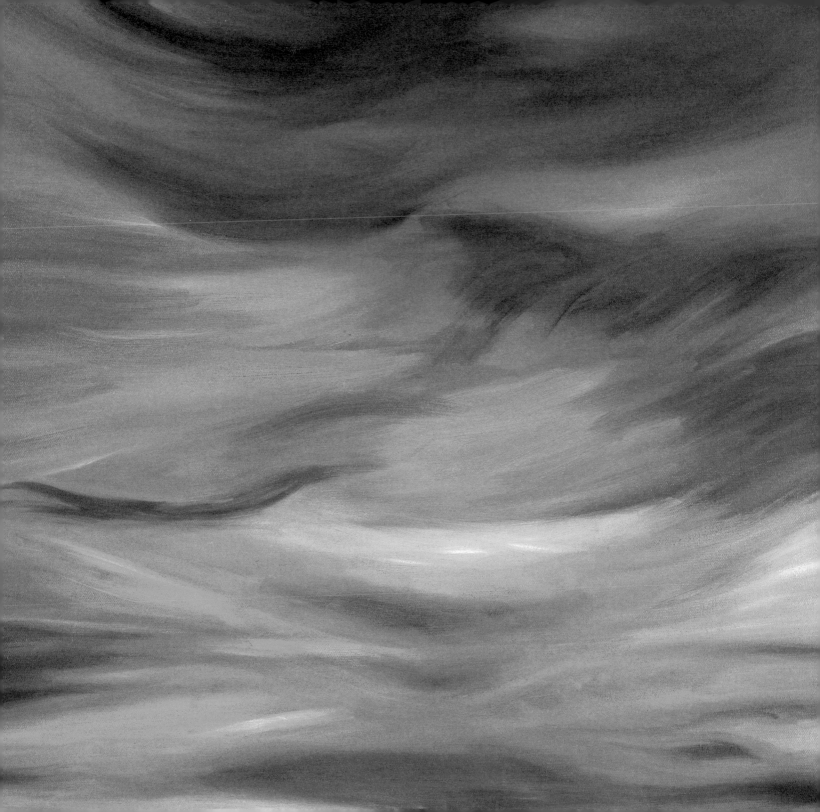